A–Z

OF

GREENWICH

PLACES - PEOPLE - HISTORY

David C. Ramzan

AMBERLEY

First published 2019

Amberley Publishing
The Hill, Stroud, Gloucestershire, GL5 4EP
www.amberley-books.com

Copyright © David C. Ramzan, 2019

The right of David C. Ramzan to be identified
as the Author of this work has been asserted in
accordance with the Copyrights, Designs and
Patents Act 1988.

ISBN 978 1 4456 8907 4 (print)
ISBN 978 1 4456 8908 1 (ebook)

All rights reserved. No part of this book may
be reprinted or reproduced or utilised in any
form or by any electronic, mechanical or other
means, now known or hereafter invented,
including photocopying and recording, or in
any information storage or retrieval system,
without the permission in writing from the
Publishers.

British Library Cataloguing in Publication Data.
A catalogue record for this book is available
from the British Library.

Typesetting by Aura Technology and Software
Services, India. Printed in Great Britain.

Contents

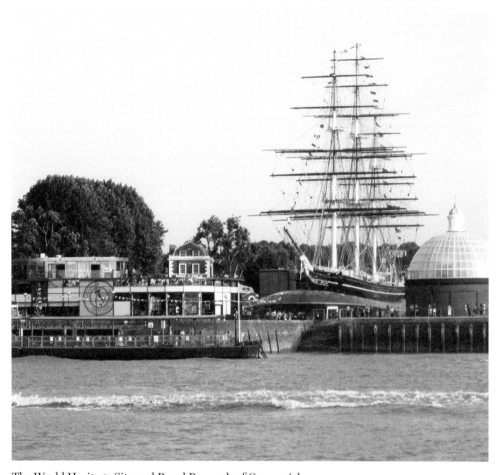

The World Heritage Site and Royal Borough of Greenwich.

Introduction

The historic Royal Borough of Greenwich, the place where I was born and raised, was well known for its magnificent maritime, military and civil architecture, royal park, light industry, manufacturing and boatbuilding. The streets where I played consisted of a variety of Regency, Victorian and Edwardian properties in a suburb of London situated on the South Bank of the River Thames. Greenwich was predominantly a working-class town, where thousands were employed by various riverside industries, royal dockyards and military establishments. At the centre of Greenwich hundreds of naval personnel were educated at the Royal Naval College, the classically built former Royal Hospital for Seamen, erected on the foundations of the original fifteenth-century Greenwich Palace. With so much history literally on my doorstep, my friends and I grew up enthralled by stories about Greenwich, of historic battles, ancient kings and queens, heroic generals and sea captains, and the industrial inventions and innovations that placed our town on the international map. Within this publication I will attempt to lead the reader, from A to Z, through the unique and remarkable history and heritage of Greenwich, recalling the many stories and legends of times past and sharing my memories of the places, people and incidents that brought fame, fortune and world recognition to the place of my birth.

Greenwich, centre of the world.

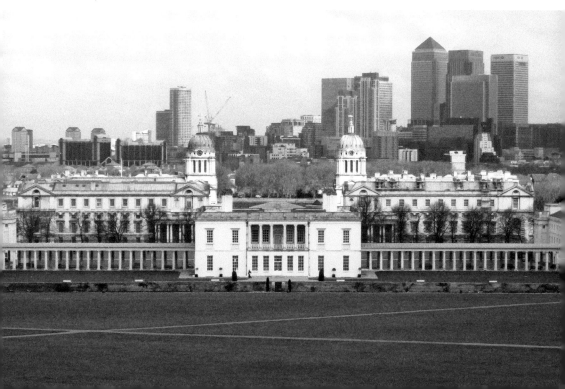

Alfred the Great

As a youngster growing up in Greenwich my friends and I were familiar with tales of the kings, queens, castles and palaces associated with our hometown; one such story connected Greenwich with the first King of England. Alfred the Great inherited the manor of Grenewic (an Anglo-Saxon term describing a green settlement) from his father Ethulwulf, King of Wessex. Fourth in succession to the throne, Alfred reigned as King of the West Saxons from AD 871 to 899, later taking the title 'King of all England'. The Anglo-Saxons occupied Greenwich from between the sixth and tenth centuries. One of the earliest existing documents recording land ownership of Greenwich dates to AD 918: a transfer of land to St Peter's Abbey, Ghent, granted by King Alfred's daughter Ælfthryth. Although England came under Norman rule, Anglo-Saxon kings held court at the manor of Greenwich up to the reign of Edward I.

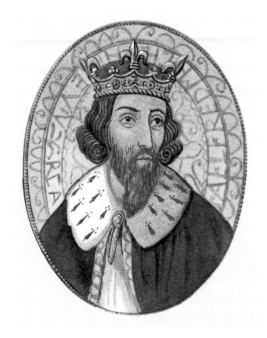

King Alfred the Great, owner of the manor of Greenwich during the ninth century.

Armouries

After watching television serials during the early 1960s such as *Ivanhoe* and the *Adventures of Sir Lancelot*, dressed in plastic armour and wielding a wooden sword, I would go out into my back garden to challenge my friend who lived next door in combat, his sister acting out her part as damsel in distress. Then later, when on a school trip to the Tower of London, we discovered real suits of armour on display had been made at Greenwich. Following Henry VIII's accession to the throne in 1509, the king founded an armoury built next to the Greyfriars monastery at Greenwich Palace, engaging expert armourers from Milan and Brussels to bring their skills to England. Erecting a tiltyard in the palace grounds, Henry, wearing a full set of Greenwich-built armour, competed in many jousts until falling from his mount, the horse, also dressed in armour, collapsing on top of him. Although knocked unconscious for two hours, the king recovered from the fall, but never took part in jousts again.

The English-made armour, evolving into a well-recognised style of its own, continued to be made at Greenwich up until Parliamentarian forces occupied Greenwich Palace during the English Civil War. Although Greenwich armourers were reinstated for a short period after the Restoration, when armour had to be made thicker for protection against powerful firearms, it became too heavy and cumbersome to wear during combat. The trade eventually went into decline and the Greenwich armouries were closed and the workshops pulled down.

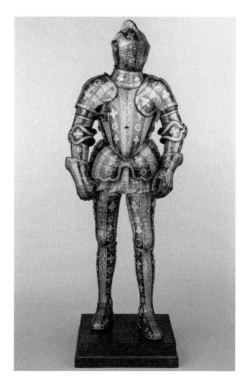

Greenwich armour made for the 3rd Earl of Cumberland, *c.* 1586.

Angerstein Lane

Between Shooters Hill and the Old Dover Road, Blackheath, there is a triangular area of land in the parish of St John's that I often walked through on way home from secondary school. The properties – tall, three-storey, late Victorian and earlier Edwardian villas – once the residencies of wealthy merchants, shipbuilders, bankers and industrialists.

To the west of the parish runs Angerstein Lane, a once unkempt right of way that over many years has been transformed into a pleasant garden oasis. Named after John Julius Angerstein, a wealthy businessman and Lloyd's underwriter, believed to have been born out of wedlock in 1732, the newborn was given the surname of the doctor who delivered him at St Petersburg, Russia, his parents believed to have been Empress Anna of Russia and Andrew Thompson. Arriving in England when fifteen years old, Angerstein worked in the London Counting House of Andrew Thompson, and by 1770 became a well-established broker at an office in Cornhill. Working in a succession of partnerships until retiring from the city in 1810, Angerstein acquired land for commercial use at East Greenwich and at a picturesque area of Westcombe to build a villa – the Woodlands. A patron of contemporary artists and writers, Angerstein amassed a small but valuable collection of art, purchased after his death in 1823 for the nation, the foundation of the National Gallery. Along with the lane, a hotel on Woolwich Road has been named after Angerstein, as well as a freight line and wharf on Greenwich Marsh.

Former coach road – Angerstein Lane, Blackheath, leading to Langton Way.

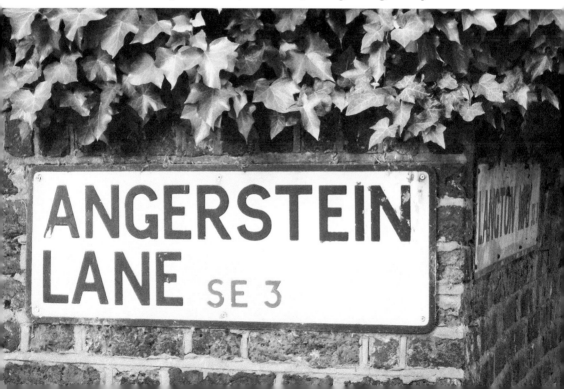

Above: Informal wild garden planted by a local resident of Angerstein Lane.

Below: Converted stables and coach houses to the rear of Victorian and Edwardian villas.

Burrows

Towards the west of Greenwich Park in an area of open grassland where people often sit for a picnic, is the site of a large Anglo-Saxon cemetery. All that remains of this historic burial ground are a few modest mounds. When building began on the Kent Waterworks reservoir during the mid-1800s, many of the burrows were dug up, prompting protests over the wanton destruction of these ancient monuments, the objections coming to the attention of Parliament. Although the reservoir was ordered to be moved further south, to preserve the surviving burrows, many artefacts had already been lost.

Several burrows had previously been excavated in 1784 by an elected fellow of the Society of Antiquaries, Reverend James Douglas, one of the first Saxon burrow archaeologists of the time. His finds included an iron knife, coloured glass beads, a large spearhead, a remnant of cloth and some auburn human hair. During the digging of the reservoir it was alleged workmen discovered a human skeleton, leading to speculation the burrows belonged to ancient warriors killed in battle, or perhaps the remains of Cornish rebels who died at the Battle of Blackheath. The most common form of tumulus, the upturned dish-shaped mound, usually surrounded by a ditch, had been used throughout prehistory for pagan burials up until the sixth century, and it has been suggested the Greenwich Park burrows may date to the Bronze Age, reused by the Anglo-Saxons to create a link with the previous inhabitants.

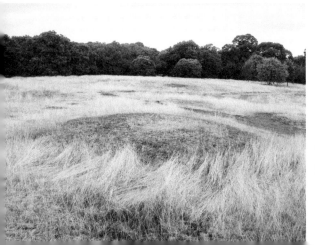

The dry summer of 2018 left the park grass scorched, making the Bronze Age burrows easily recognisable.

Bugsby Marshes

One of my favourite activities when young was cycling with friends along the Thames Path, past the riverside industries and onwards to Bugsby Marshes, the northerly part of Greenwich Marsh. It was here where legend has it executed pirates were hung in iron cages or chains for birds to peck at their decaying remains. Since the early eighteenth century at least one gibbet stood at Greenwich Marsh, near Bugsby Reach, where bodies were hung in sight of passing ships, serving as a warning to those contemplating carrying out acts of river piracy and smuggling. There were many tales and legends as to how this once desolate area of marsh acquired the name Bugsby, from associations with a robber of the same name, who allegedly had a hideaway close by, to suggestions it was once known as Bug's Marsh, haunted by 'bogey' men, perhaps the ghosts of scoundrels hung on the gibbet.

Records of those hung on the marsh are scarce. However, in a 1735 publication, *Gentleman's Magazine*, it was reported a pirate named Thomas Williams who stole and sold a ship, the *Buxton Snow*, after cutting the captain's throat with an axe, was hung at Execution Dock, Wapping, before his corpse was gibbeted at Bugsby Hole, east of Greenwich Marsh. There is also mention of the bodies of four men hung in chains on a cross-headed gibbet situated below Blackwall Point, on the South Bank of the Thames, after caught attempting to retrieve chests of American dollars hidden on the foreshore, stolen during transfer onto a ship bound for India.

Bugsby Marsh, *c.* 1782, and the gibbet on the foreshore at Blackwall Point.

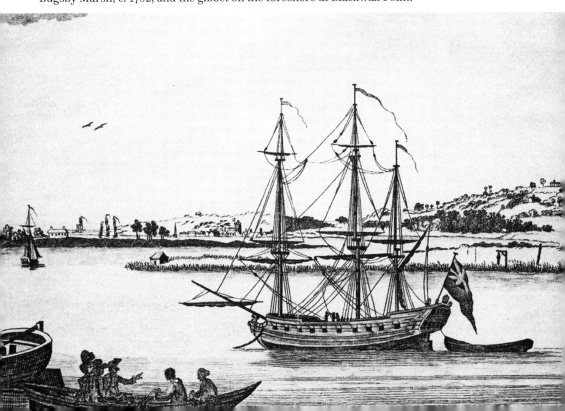

Billingsgate Dock

Another riverside place associated with Greenwich seafarers – fishermen rather than pirates and smugglers – was Billingsgate Dock, situated to the west of the Greenwich Pier. Home to a large fishing fleet since the early 1400s, the boats supplied river and sea caught fish to local markets. Thames Peter boats, many built at boatyards along the Greenwich foreshore and Greenwich Marsh, brought in catches of salmon, roach and whitebait.

Shellfish was also in plentiful supply and was sold to the many riverside inns and taverns. Through an increasing high demand for fish, larger boats were built to sail for the fishing grounds of the North Sea, the Greenwich fishing industry prospering up until development of steam railways. After fish caught by northern-based boats was transported south by freight train faster than Greenwich vessels were able to bring back their own catches, the Greenwich fishing fleet failed economically, the fishermen and their families were forced to relocate to England's north-east coastal fishing towns.

Billingsgate Dock prior to demolition, *c.* 1937, once central to the Greenwich fishing industry.

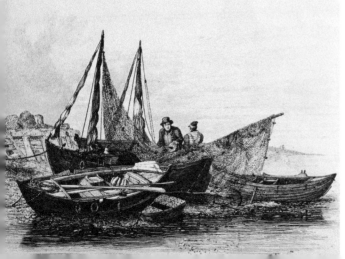

Greenwich clinker-built Peter boats, early 1800s.

C

Cowboy Land and Celtic Warriors

When my friends and I acted out the Battle of the Little Big Horn on an area of Blackheath we called 'Cowboy Land', old gravel pits now covered in trees and gorse bushes, the gravel once dug out for ships ballast, little did we know at the time a medieval battle had occurred close by, where bows and arrows had been in use as deadly weapons of war.

The Battle of Blackheath took place on 22 June 1497 after around 10,000 rebels (the majority being Cornish bowmen), protesting against high taxation, marched towards London through the southern counties to encamp upon the heath before

Cowboy Land (formerly gravel pits), Blackheath.

Memorial plaque at Blackheath commemorating Michael Joseph and Thomas Flamank, leaders of the Cornish rebels, *c.* 1497.

engaging Henry VII's forces in battle. The king's army, commanded by seasoned campaigner Lord Daubeney, was waiting below Blackheath, near Deptford Strand, when the rebels advanced down the hill, the Cornish archers firing volleys of arrows into their ranks. Although Lord Daubeney was captured during a skirmish near Deptford Bridge, the rebels let him go and, rallying his troops in a counter-attack, the rebels were pushed back up onto the Blackheath. Encircled by a detachment led by the Earl of Oxford, some 2,000 rebels were slain and around 1,500 taken prisoner, the remainder taking flight to escape across country.

The bodies of the rebel dead were reputedly buried under a mound on the heath, known today as Whitfield's Mount, named after eighteenth-century preacher George Whitefield, who held sermons there. The mound was also used as a rallying place in 1381 by Wat Tyler, leader of the Peasants' Revolt, and to the west of the mound, in 1450, Jack Cade held council with a band of rebels in caverns below the heath's surface.

Castle of Greenwich Park

Not to be confused with the mock-medieval Vanbrugh Castle, the fortification known as Greenwich Castle was positioned at the highest point in Greenwich Park, overlooking

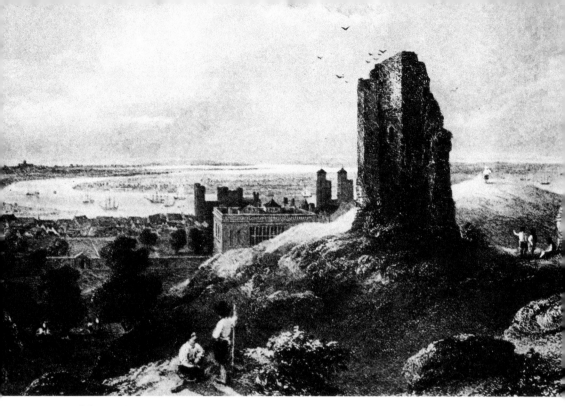

Ruins of the castle at Greenwich, Duke Humphrey Tower, mid-1800s.

the Thames and the small fishing village below. Erected in 1433 by Humphrey, Duke of Gloucester, younger brother of Henry V, the fortification was built in the form of a square buttressed tower. Unlikely to have ever served as a defensive structure, the castle was mostly used as a royal hunting lodge. Refurbished and enlarged as a royal residence by Henry VIII when holding court at Greenwich Palace, it was where he held secret liaisons with his mistresses while married to Anne Boleyn. Further construction works were carried out by the park ranger, Lord Northampton, in the early seventeenth century. The castle was used occasionally as a prison, as well as a look-out post by Parliamentarian soldiers to prevent theft of park deer.

After the restoration of the monarchy the castle was used as a 'butt', a target for military gun practice, described by John Evelyn in an entry in his diary dated 1 June 1667, 'I went to Greenwich, where his Majesty (Charles II) was trying divers granados shot out of cannon at the Castle Hill from the house in the park'. Left to fall into ruin, Greenwich Castle was demolished in 1675, the site used for the construction of the Royal Observatory.

Conduits

At the base of One Tree Hill to the east of Greenwich Park is a large brick-built curved structure resembling an ancient doorway, now bricked up, set into the hillside, which local schoolchildren from years gone by believed led you down a tunnel to a place

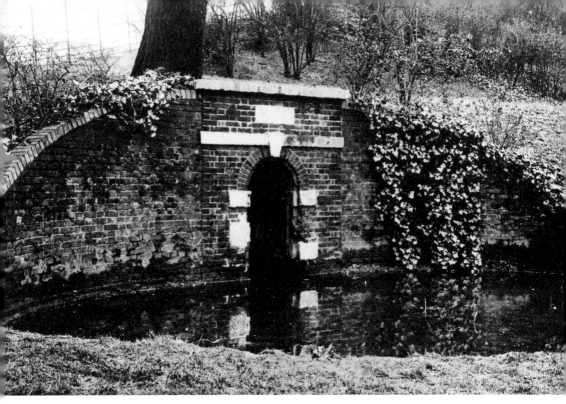

Grade II listed One Tree Hill conduit head, late seventeenth or early eighteenth century.

inhabited by ghouls and goblins. To youngsters of today, however, the structure most likely resembles the former home of a hobbit who set off on a quest and failed to return. This mysterious and intriguing doorway is a redundant conduit head, part of an early underground conduit system that leads into a labyrinth of tunnels running under the park, once supplying groundwater to the Old Royal Hospital.

The earliest subterranean watercourse, the Arundel Conduit, dating to 1268, carried water to Crown stables near Ballast Quay, while other conduits dating to the Tudor period supplied water to the Palace of Placentia. At one time water spilling out of One Tree Hill conduit head formed a shallow pool, the open archway large enough to walk through before iron bars were installed to prevent entry. Conduit heads and houses are extremely rare; of the thirty-three listed in England, two are situated in Greenwich Park, attributed to architect Nicholas Hawksmoor, Greenwich clerk of works.

At one time there were several conduit heads located throughout Greenwich. Of the two that remain, a red-brick conduit head is situated at West Grove, Blackheath, and the other, a stone built conduit head and cattle trough, can be found at the junction of Blackheath Hill and Hyde Vale.

D

Deptford Creek

To those of us born and raised in Greenwich, Deptford Creek was the recognised border separating Greenwich from Deptford, with Creek Bridge regarded as our 'Check Point Charlie' between the two communities. Of course there were no sentries on guard to stop you crossing; however, on occasion the bridge operators in their control room brought traffic and pedestrians to a halt when flashing red signal lights warned they were about to bring the barriers down, before raising the bridge to allow a vessel to pass through.

Dutch cargo vessel *Wilhelmina-V* at the mouth of the tidal creek dividing Greenwich and Deptford, *c.* 1970.

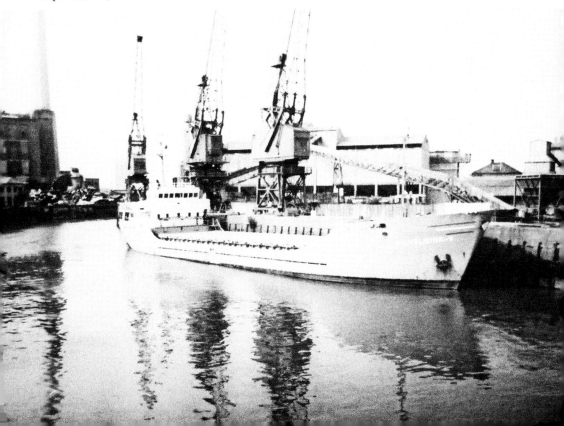

Before the first bridge was built in 1805, a ferry, operating since the mid-seventeenth century, was the only means of moving goods and passengers across the creek at its most northern point. It was at Deptford, west of the creek, where Henry VII established a repair and maintenance yard for his ships, the yard transformed by Henry VIII into a royal dockyard. From the sixteenth century onwards, various trades and mercantile industries developed along both sides of the tidal creek from the Thames towards Blackheath Road. When Francis Drake returned from his voyage of discovery on the *Golden Hind*, the galleon loaded with enough plundered Spanish treasure to pay off the government's debt, the privateer was hailed as a national hero and knighted in 1851 by Elizabeth I aboard ship moored off Deptford Creek. Although the queen commanded the *Golden Hind* should be preserved as a museum, the ship, neglected during the English Civil War, began to rot away and was eventually broken up. A few of the vessel's more sound timbers were made into items of furniture.

Close to where the *Golden Hind* was dismantled, Peter the Great learned how to construct ships while studying English methods of shipbuilding in 1698. A statue of the tsar, a gift from the Russian people commemorating his visit, was erected overlooking Deptford Creek and unveiled in 2001.

Peter the Great and his court dwarf statue.

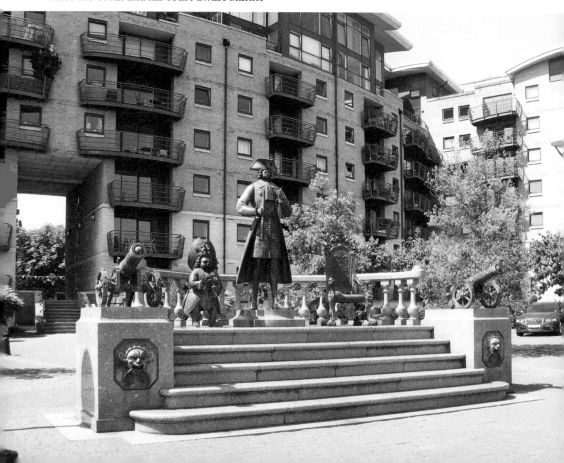

Deptford Creek leading out into the Thames. The swing bridge control tower is to the left.

Duke of Gloucester

From the age of around eighteen, when my friends and I began to socialise in local public houses, one of our favourite places to visit was the Gloucester Arms (named after the Duke of Gloucester, Humphrey of Lancaster, fourth son of Henry IV), the mid-nineteenth-century hostelry located opposite Greenwich Park's St Mary's Gate on King William Street. Acquiring Old Court from his uncle Thomas Beaufort, from where the manor of Greenwich was administered, the duke enclosed 200 acres of parkland for use

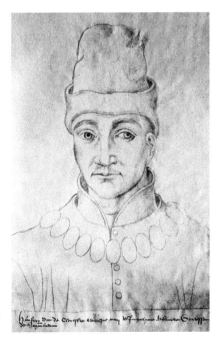

Humphrey, Duke of Gloucester, administrator of the manor of Greenwich, early thirteenth century.

as a royal hunting ground and erected a fortified tower, Greenwich Castle. Gloucester, a campaign commander during the Hundred Years' War, fought at the Battle of Agincourt and after the death of his brother, Henry V, governed the country as regent on behalf of his nephew. In 1428, Humphrey built Bella Court, a riverside property later transformed into the Palace of Placentia. After the annulment of his first marriage, the extremely popular duke, referred to by the people as 'Good Duke Humphrey', married Eleanor Cobham, the manor becoming a centre of poetry and learning.

A majority of the duke's manuscripts and publications would later be left to the University of Oxford, forming the basis of the Bodleian Library. Continually at odds with his half-uncle and rival Cardinal Beaufort, the duke was arrested for treason and accused of plotting to seize the throne, a charge most likely instigated by Beaufort and the Duke of Suffolk to remove Humphrey from his position of power. Previously Humphrey's wife had been forced to divorce him and spend the remainder of her days in prison after found guilty of practicing witchcraft against the king, an attempt to retain power for her husband. Humphrey later died while under arrest at Bury St Edmunds in 1447.

Dome

For anyone old enough to witness the bicentennial celebrations at the end of 1999, none would fail to remember the enormous edifice, erected to the north of Greenwich Marsh, nicknamed the Great White Elephant. The Greenwich Dome, now known as the O2 arena, was built on disused industrial land once owned by Morden College. With the Meridian Line running close to the north-west corner of the Marsh, the site was an ideal location to build a futuristic exhibition centre to celebrate the second millennium. Designed by architect Richard Rogers, the Dome, measuring 365 meters in diameter (each meter representing a day of the year), was made up from sections of white tensioned fabric stretched over a massive steel frame. It is supported by twelve tubular struts and a network of high-tension cables, with each strut matching the hours on a clock face, the number corresponding to the months of the year.

The interior housed the Millennium Experience, an exhibition divided into themed zones with a central performance stage. Opening to the paying public on 1 January 2000, the project cost around £780 million to stage, and although the exhibition briefly entertained visitors, attendances fell well below the expected numbers and the Millennium Experience almost fell into bankruptcy. After the year-long exhibition came to a close, it was estimated the Dome cost £1 million a month to maintain. In an attempt to recoup some of the expenditure, the venue was hired out for themed events and concerts.

Rejuvenated when acquired in a sponsorship deal with European telecommunications company O2 in 2005, the Dome became a financially successful state-of-the-art concert, sport and exhibition centre, hosting gymnastics and basketball events at the London Olympics in 2012.

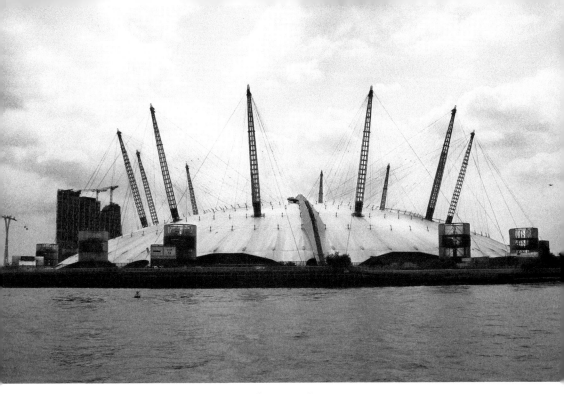

Above: The Millennium Dome on Greenwich Peninsula.

Below: Now known as the O2, the Dome's main entrance is on Peninsula Square.

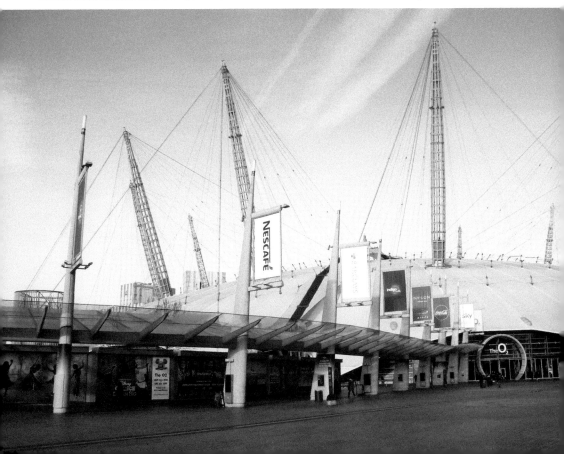

East Greenwich

The industrial side of Greenwich, including the former marshland of the Greenwich Peninsula, historically lay to the east of the Meridian Line, where I was born. By the mid-1800s, industrialist George Russell created New East Greenwich, consisting of a large corn-grinding tidal mill, terraced houses for the millworkers, and a public house (the Pilot) where his employees were able to take refreshment after a long, hard day's work.

During the early 1970s, I took up a part-time job serving behind the bar of the Pilot, frequented in those days by Thames Watermen and Lightermen, trading and selling cigarettes, tobacco and bottles of spirits acquired from crews of foreign vessels moored on the Thames. The tidal mill was converted into a chemical works before being demolished and replaced by a coal-fired power station. In the 1880s, the South Metropolitan Gas Company established the East Greenwich Gas Works and various riverside boat and shipyards, light and heavy industries occupied sites all along the riverside and across vacant land of East Greenwich – cement and aggregate works,

Industry of East Greenwich and Greenwich Marsh 1950–70.

soap makers, chemical refineries, structural engineers, scrap metal merchants and marine engineers. Although a flourishing working community evolved at East Greenwich, where row upon row of terraced houses were erected to accommodate the local workers, after suffering from bombing raids during the Second World War many of the industries gradually fell into decline.

Elizabeth I

In 1533, the most famous queen in English history was born at Greenwich Palace: Elizabeth Tudor, daughter of Henry VIII and Anne Boleyn. The Palace of Placentia became Elizabeth's main royal residence and principal seat of court following her coronation in 1558. Elizabeth encountered Walter Raleigh for the first time at Greenwich when the Devonshire nobleman laid his cloak down over a puddle for the queen to walk upon. During the early period of Elizabeth's reign, Catholic supporters of her cousin, Mary, Queen of Scots conspired to have Elizabeth removed from the throne in favour of the Scots queen.

Elizabeth, in response to threats from Catholic conspirators, held a military review in Greenwich Park, where a compliment of 1,400 soldiers gathered as a show of force to those plotting against her. When Mary was arrested and charged with treason, Elizabeth reluctantly signed her cousin's death warrant at Greenwich in 1587. Seven years after Drake was knighted at Deptford Creek, England came under threat

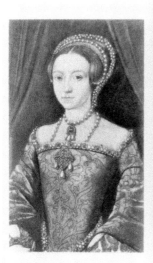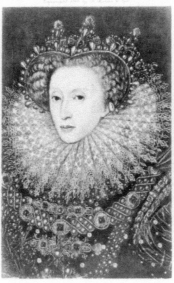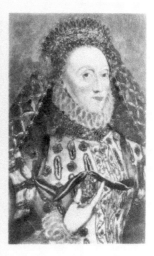

Elizabeth I, born at the Palace of Placentia, Greenwich, September 1533.

of invasion by Spain in 1588, and it was at Greenwich Palace where Elizabeth and her naval commanders drew up plans to engage the Spanish Armada sailing from Cadiz. Then, after the English fleet's victory over the Spanish, a parade was held at Greenwich Palace displaying captured Spanish treasure.

Egyptian Statue

In the grounds of the Royal Arsenal at Woolwich, a weathered white marble statue, seemingly of little importance, erected on a plinth outside the former Royal Brass Foundry, is the oldest monument in the borough of Greenwich. Unseen by the public until after the Royal Arsenal closed in 1994, the statue, dating from the late Roman period, between the first century BC and third century AD, was dug from the sands of Alexandria in 1801 by British troops stationed in Egypt. The statue was then loaded aboard a ship and transported to England.

The Turkish marble statue symbolised the male counterpart of Dea Luna, the female embodiment of the moon, described by ancient mythologists as representing both sexes, Deus Lunus, originally worshipped by the Syrians. The important Roman antiquity, travelling over 3,600 nautical miles from Egypt to south-east London, was erected facing the south-west corner of Dial Square workshops, where pieces of Roman pottery of a similar age to the statue were discovered during excavations, providing evidence the Romans encamped in Woolwich around the same period Deus Lunus had been carved.

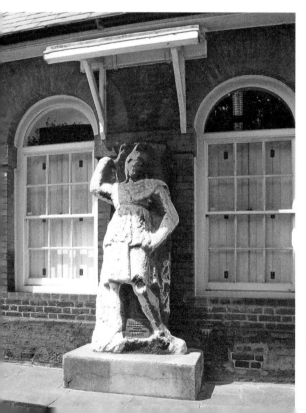

Deus Lunus, God of the Moon, Woolwich Arsenal.

First Pensioners

Admitted to Greenwich Hospital in 1705, the first pensioners were retired and injured sailors of the Royal Navy, some of whom had fallen on hard times and were without the means to care for themselves. Life at sea during the age of sail was a dangerous occupation, where accidents and disease were more common than suffering injuries through battle. The buildings where the first pensioners were housed included accommodation cells (rooms with a bunk, small desk and storage for clothes); a chapel; brewery; bowling alley; and large refectory, the Painted Hall, magnificently decorated with murals painted by Sir James Thornhill in honour of William and Mary.

Below left: Royal Hospital Pensioners taking refreshment at a Greenwich Tavern, late 1700s.

Below right: Poster promoting the Greenwich Pensioners' cricket match, *c.* 1852.

Considered too grand a place for pensioners to eat, they were moved to the vaulted undercroft and the Painted Hall became a tourist attraction, with pensioners charging a fee for admittance. Dressed in traditional dark blue frock coats and black tricorn black hats, pensioners earned their keep carrying out chores. Pensioners would often be seen frequenting local inns and taverns recalling adventures at sea in return for a drink or two, as well as entertaining the public at sporting occasions.

Although pensioners were at liberty to leave the hospital and mingle with the general public, their conduct was carefully scrutinised. Punishments for bad behaviour or drunkenness included confinement to the hospital, fines, a diet of bread and water and the humiliation of being ordered to wear their frock coat inside out, revealing the yellow lining, indicating the pensioner had misbehaved.

Flamsteed House

Erected on the site of Greenwich Castle ruin, Flamsteed House, the first Royal Observatory building, was constructed within a year of commission using materials salvaged from the Tower of London and unused bricks from Tilbury Fort, Essex. Designed by Sir Christopher Wren under instructions from Charles II, the building, completed in the summer of 1676, was named after the first appointed Astronomer Royal and layer of the foundation stone, John Flamsteed.

Flamsteed House, historic home to Britain's Astronomers Royal from the late seventeenth to twentieth centuries.

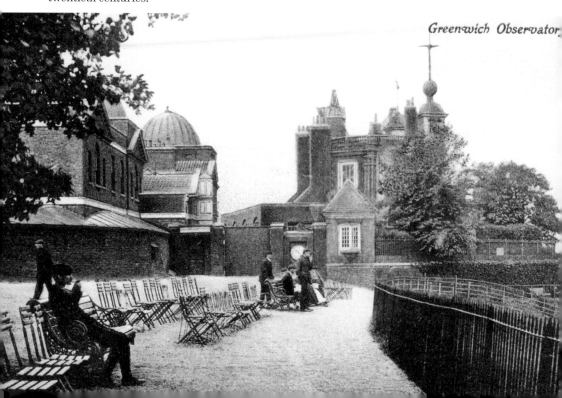

Greenwich Observatory

Admitted as a Fellow of the Royal Society in February 1676, with an allowance of £100 a year, Flamsteed moved his family into the new observatory building's residential quarters below the magnificently decorated Octagonal Room. The Astronomer Royal spent his working hours producing a series of star maps from observations made of the night sky through a transit telescope housed in a brick building and from the bottom of a 100-foot-deep well telescope – both located in the garden.

Foot Tunnel

Riding bikes through Greenwich Foot Tunnel is strictly forbidden; however, when my friends and I were younger, on exiting the lift at the bottom of the shaft and when out of sight of the lift attendant, instead of pushing our bikes along we would jump back on and cycle as fast as we could through the tunnel, hoping not to be caught by the lift attendant at the opposite end. Designed by Sir Alexander Binnie, the tunnel was constructed to allow workers to cross the river for free between Greenwich and the Isle of Dogs, entering and exiting the tunnel at each end by way of a spiral staircase or lift housed within glass-domed, circular brick buildings. Construction began in 1899 and by 1902 the tunnel was completed and opened to the public. Clad in cast-iron rings, coated in concrete and lined with 200,000 ceramic tiles, the tunnel, 370 meters long, suffered bomb damage at the northern end during the Second World War. Strengthened by applying layers of concrete and reinforced with curved steel panels, the repairs can still be seen by foot passengers, as well as cyclists, passing through the tunnel today.

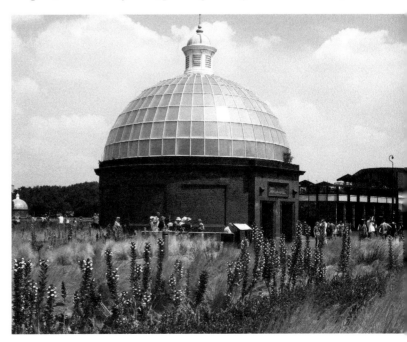

Greenwich foot tunnel entrance, southern side.

Gunpowder Magazine

The earliest recorded gunpowder store in Greenwich was situated at the Palace of Placentia where armaments were made on-site. After the Restoration, Charles II commissioned the building of a new palace; however, after only one wing was completed the project came to a halt, and by 1694 the King Charles II Quarter became a gunpowder store. When Sir Christopher Wren received a commission to complete the building after William and Mary assended the throne, £500 was made available to clear the gunpowder. Although there are no records of how this explosive material was transported, it was moved to Greenwich Marsh for storage in the Board of Ordnance gunpowder magazine.

Originally an Elizabethan watchtower, the building was transformed into a large magazine where newly milled gunpowder was stored prior to distribution by ships

Gunpowder Magazine, Greenwich Marsh, c. 1738.

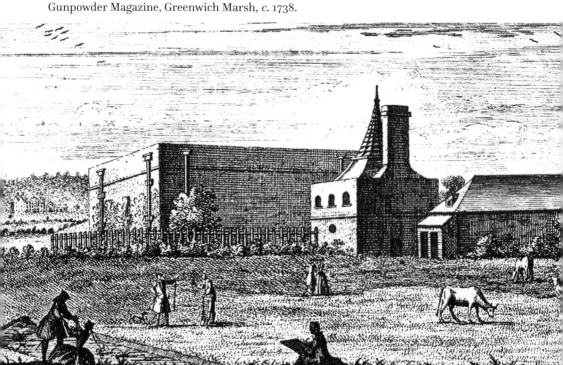

loaded at Magazine Wharf, the magazine holding over 6,000 barrels of gunpowder, weighing some 250 tons. Although constructed in a manner to lessen severe damage should an explosion occur, by the mid-eighteenth century the building was in such poor condition props were needed to hold up the walls on all sides. It was estimated that if ever an explosion had taken place, the force would have destroyed a majority of Greenwich, the Royal Greenwich Hospital, the royal dockyards at both Deptford and Woolwich, and the ships at anchor or sailing along that stretch of the Thames. As the local population grew in number, for the safety of the people, several noblemen, gentlemen and residents of Greenwich petitioned Parliament requesting the magazine be moved. A committee was immediately appointed to consider the petition and calculate the cost to build a new magazine and move the gunpowder away from the highly populated area. So serious was the situation that a bill was passed by both Parliament houses almost immediately, the magazine relocating to Purfleet on the Essex marshes.

Greenwich Mean Time

'Where exactly does time begin?' I remember my teacher asking us all during a lesson at school, various classmates' hands going up eager to give an answer. 'At Greenwich Mean Time!' one called out – something we had learned while on a school trip to the Old Royal Observatory where we all stood in line astride the Meridian Line. Dividing the globe down its centre into hemispheres east and west, the Meridian Line was

Greenwich Meridian Line, late 1800s, transecting Greenwich Park public footpath.

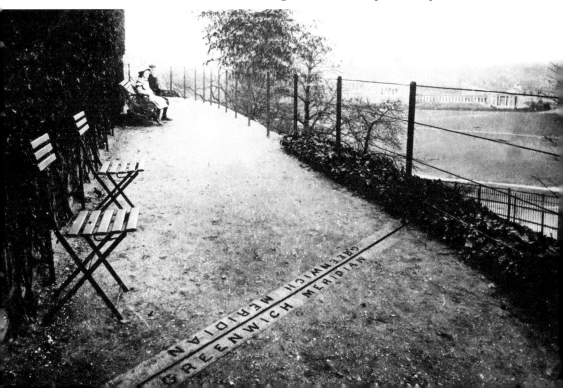

marked by a brass metal strip running across the observatory forecourt, down a boundary wall, and over a pedestrian pathway.

Greenwich Mean Time was adopted across Great Britain in 1847 by the Railway Clearing House, an organisation that managed the allocation of railway revenues. First applied by the Great Western Railway and then by a majority of railway companies the year after, all train times were calculated to correspond nationally with GMT. In 1884, at the International Meridian Conference in Washington DC, representatives of twenty-two countries voted to elect a central location from where all time zones around the globe would be set and measured. Greenwich was designated as the Prime Meridian after winning the vote.

General Gordon

General Charles George Gordon, born at Woolwich in 1792, became a national hero for sacrificing his life at Khartoum, Egypt, defending the city's population against attack by overwhelming forces of the Mahdi. Gordon of Khartoum, as the general became known, was portrayed in the 1966 film *Khartoum* by one of my favourite actors at the time, Charlton Heston. The movie was based on historical accounts of the defence of the Sudanese city. Son of a major general, his parents Henry Gordon and Elizabeth (Enderby) Gordon married at Greenwich on 31 May 1871. Gordon's mother was the daughter of Samuel Enderby Jr, a member of the whalers and sealers Samuel Enderby & Sons. Elizabeth resided at Crooms Hill before her marriage. The young Charles Gordon along with his three brothers were destined to become military men, following on from four generations of male Gordons serving as army officers.

After attending the Royal Military Academy at Woolwich, Gordon served with the Royal Engineers, seeing action in the Crimea War and then, while serving in China, supported the Manchu-led Qing dynasty during the Taiping Rebellion. Despatched to Eastern Europe, Gordon made the acquaintance of the Egyptian prime minister, who secured Gordon's services in 1873 with permission of the British government to serve under the Ottoman Khedive, governor of Egypt and the Sudan, where Gordon was active in suppressing uprisings, revolts, floggings, beheadings, and the trading of slaves. After seven years of exhausting work, Gordon resigned his post and returned to England. When a serious revolt broke out in the Sudan, the British government, unwilling to commit troops, requested Gordon to return to the Sudan with orders to evacuate civilians and troops from Khartoum, the city coming under attack from the forces of self-proclaimed Mahdi, Muhammad Ahmad. In 1884, before heading for the Sudan, Gordon spent his last night with family members at Enderby House, on Greenwich Marsh. On arrival at Khartoum, Gordon began evacuating the city's civilians and the British and Egyptian troops. Then, acting on his own initiative, he organised the city's defences in readiness for imminent attack. Although Gordon and the Mahdi had been in correspondence with each other in an attempt to resolve

Gordon at Khartoum,
c. 1885.

the volatile situation, neither would back down and Khartoum came under a year-long siege. Outraged by the government's decision to abandon Sudan, the British public demanded the government send a relief force when news arrived of Gordon's heroic stance at Khartoum. Severely delayed on route along the Nile, the relief force arrived in January 1885, two days after the city had fallen and Gordon, along with the defending troops, had been killed during a full frontal attack by the Mahdi's army. Although reports of Gordon's death varied, the consensus was he fought bravely to the end, struck down and killed on the steps of the governor general's palace. To honour Gordon a square was named after him at his birthplace in Woolwich, and one of the first Woolwich steam ferries when launched was christened *Gordon*.

Hauntings

Unsurprisingly, with its long and sometimes turbulent and bloody history, there have been numerous reports of hauntings occurring throughout Greenwich. Ask children if they believe in ghosts, ghouls and spooks, a majority will answer yes, even though psychological research suggests most children can differentiate fantasy from reality. It was much the same with my friends and me when young, ready to believe stories of scary apparitions and haunted happenings. The family of one of my friends, living across the road from my house, believed their home was haunted by an old lady with staring red eyes, who would sit in a chair opposite my friend's bed during the night, and neighbours passing the house often said they had seen the figure of an old lady gazing out at them from the living room window when they knew no one was at home.

One haunting from Greenwich's earliest period of history were a troop of Roman soldiers, said to have been seen by maintenance workers at the Old Royal Naval Hospital, marching in formation through one wall of the undercroft before disappearing through an opposite wall.

A former governor of the Royal Hospital was seen after his death sitting contently reading a book in the library before getting up and walking straight through a set of locked doors, and in 1999 the unearthly figures of several Greenwich friars, believed to have been incarcerated during the Reformation in the Tower of London, appeared in front of a hospital chapel cleaner. Thirty years earlier, workmen discovered five skeletons buried in College Way, the remains believed to be those of the friars who were returned for burial at Greenwich after dying while locked up in the tower.

Several long deceased hospital pensioners have been observed wandering the colonnaded walkways, and on one occasion at a ceremonial dinner in the Painted Hall guests witnessed a man dressed in yeoman pensioner's clothes passing between their tables. Believing him to be part of the ceremonial dinner, guests were later told that no one in attendance that evening had been dressed in period costume.

Admiral Byng, sentenced to death by firing squad for failing to do his duty at the Battle of Minorca, is said to walk the floor of Queen Anne Court where he was held under arrest before court-marshal and shot. There are also reports of Henry VIII's second wife, Anne Boleyn, roaming the grounds close to where arrested for treason.

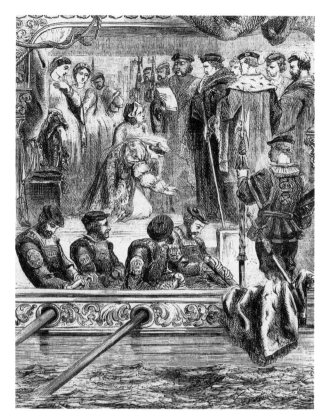

Right: Queen Anne Boleyn's arrest in May 1536 at Greenwich Palace.

Below: Cartoon depicting the public demanding an enquiry into the loss of Minorca, blamed unfairly on Admiral Byng, shown pleading his case to the Admiralty, *c.* 1756.

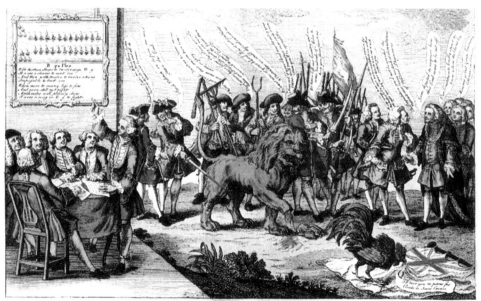

THE *ENGLISH LION DISMEMBER'D*

Or the Voice of the Public for an enquiry into the loss of Minorca ~ with Adl. B——g's plea before his Examiners

Queen Anne Quarter, Old Royal Naval College, adjacent to College Way.

There have also been sightings of an unidentified woman elegantly dressed in Elizabethan clothes and wearing a small crown – possibly good Queen Bess herself?

At Greenwich Park, in July 1898, a man sitting resting under a tree reported a strange incident claiming a half-human, half-animal figure fell from above him before scuttling off sideways, like a crab, into nearby bushes. A ghostly figure has been seen in the vicinity of the Queens House, the central building of the Maritime Museum, before disappearing through an entrance to a tunnel running under the colonnaded walkway, museum wardens reporting hearing footsteps they were unable to account for. In 1966, Reverend R. W. Hardy, while visiting the Queens House, took a photograph of the empty Tulip Staircase, and after developing the film at home was astonished to see what appears to be a shrouded figure climbing the stairway pursued by a second, and possibly a third, figure. So far, although thoroughly investigated, there has been no explanation as to how the figures appeared in the photograph. At the Old Royal Observatory, music from a harpsichord has been heard playing in the south building, witnessed on one occasion by Sir Patrick Moore, former patron of the museum.

It is alleged that over fifty ghosts haunt the Royal Arsenal site at Woolwich, including a munitions worker who died after going insane due to mercury poisoning and a prostitute who expired while hidden away in a locked basement room during a visit to the Arsenal by the Duke of Wellington. The girl's body was later found nibbled away at by rats.

Hauntings have been reported at Connaught Barracks, formerly the Royal Ordinance Hospital, where a woman dressed in Victorian nurses clothes has been observed walking the grounds. Some witnesses suggested the figure was that of Florence Nightingale, who once had connections to the hospital Lantern House named after her.

West of the barracks, at the Jacobean mansion Charlton House, many ghostly hauntings have been reported, including the figure of a grey lady carrying a bundle walking about the gardens. During restoration of the house the mummified body of a baby was discovered within an old fireplace, and it has been suggested the remains were those of a stillborn or murdered illegitimate child of a servant girl – could this

Florence Nightingale, the lady with
the lamp.

be the bundle carried by the grey lady? There have also been sightings of a wounded
sapper, possibly a lingering spirit from when the house was used as a hospital during
the First World war, and many members of Charlton House staff refuse to enter
the attic room and cellars on their own because of the frightening and oppressive
atmosphere. Whether or not you believe in the afterlife, Greenwich certainly has
many tales of paranormal unearthly hauntings.

Henry VIII

Born at the Palace of Placentia in June 1491, not far from my own place of birth five
centuries later, Henry VIII was quite possibly the most famous of former Greenwich
residents. Second son of Henry VII and Elizabeth of York, Henry was baptised at the
Church of the Observant Franciscans adjacent to the palace, spending a majority of
his early years living at Eltham Palace, around an hour's horse ride away. The young
prince was well educated in various aspects of state affairs, languages, literature,
theology, philosophy and Roman Catholicism, a religion Henry would later abandon.
Like most privileged healthy young boys of his time, Henry enjoyed a variety of
sporting activities, most of which he excelled in. After the death of his elder brother
Arthur, young Henry was betrothed to his sibling's widow, Catherine of Aragon.

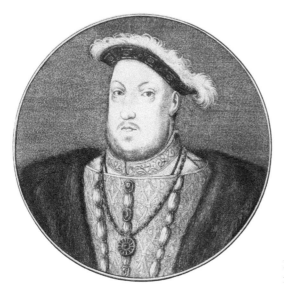

Henry VIII, *c.* 1530 – the most famous resident of Greenwich.

On the death of his father the marriage between Henry and Catherine took place at the Friars Church, Greenwich, on 22 June 1509, just two days before the coronation at Westminster Abbey. Henry and Catherine spent most of their married years together at Greenwich, the king riding out from the palace into the royal park to hunt deer or travelling with the queen in royal procession to Shooters Hill, a high forested area to the south of Greenwich where Henry took part in archery contests. At Greenwich Palace, Henry spent vast sums of money on improving his favourite royal residence, building a hawkery, kennels and stables, a tennis court, cockpit and tiltyard. It was also likely the king enjoyed a good kick about too, as it was recorded in the royal footwear collection that Henry owned a pair of football boots. During the early years of his marriage to Catherine, Henry was happy and contented reigning over the kingdom from Greenwich; however, Catherine was unable to give the king what he wanted most, a male heir. Although pregnant on seven occasions, only one child survived: a daughter christened Mary, born at Greenwich Palace in 1516. After Catherine was no longer able to bear children, Henry took up with the queen's lady-in-waiting, Anne Boleyn, marrying her in secret before divorcing Catherine. Henry's short and turbulent marriage to Anne produced one child, a girl, born on 7 September 1533 at Greenwich Palace; the baby was given the name Elizabeth after the king's mother. Anne's failure to produce a male heir brought about her eventual downfall. Following a May Day tournament held at Greenwich in 1536, soon after Henry left the palace for London, Anne was arrested and charged with treason, incestuous adultery and suspicion of practicing witchcraft. Although evidence presented against the queen was weak, Anne was found guilty and executed at the Tower of London. After Henry's third wife, Jane Seymour, died giving birth to the king's only legitimate son, Edward, Henry married Anne of Cleves at Greenwich Palace in January 1540. Towards the latter part of Henry's reign, the king spent less time at Greenwich Palace, preferring to hold court at royal residencies further upriver.

I

Inigo Jones

During the 1970s, I often walked through Charlton Village when making my way to The Valley to watch the football club I support, Charlton Athletic, playing a match on a Saturday afternoon, passing a large brick-built redundant public toilet situated on the south side of the road. At the time, little did I know, the structure, dating to the 1600s and converted into a public lavatory in 1937, was attributed to one of England's most eminent architects, Inigo Jones. The building was once the summerhouse, or orangery, of the Jacobean mansion Charlton House.

Born in July 1573 at Smithfield, London, Jones, the son of a Welsh clothmaker, was a trained painter and self-taught architect who, through his talent alone, rose to the post of surveyor-general of the King's Works. Jones has been credited for the introduction of Renaissance architecture to Britain, which is evident in his design of the Queen's House, Greenwich, the first fully classical building in England. While in his late twenties Jones journeyed to Italy, attending theatrical performances at the

Charlton House Orangery, attributed to Inigo Jones, mid-1600s.

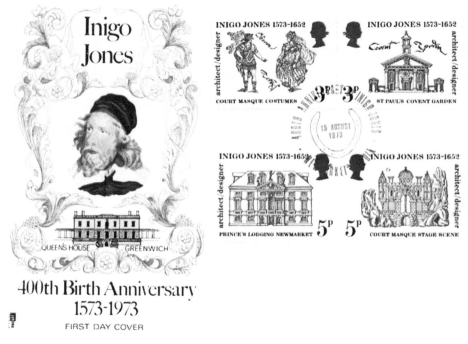

First Day Cover 400th anniversary of Inigo Jones' birth, 1573–1973.

Medici court in Florence, and on his return to England was appointed by James I to design scenery and costumes for royal masques performed at Greenwich Palace.

Influenced by Italian architect Andrea Palladio, Jones designed his symmetrically proportioned buildings in a style known as Palladian. The architect's other major works included the Banqueting House, Whitehall; the square of Covent Garden; and the adjacent actors' church, St Paul's.

Infirmary and Ships of the Line

During the age of sail, when sailors wounded or injured at sea required further medical attention on return from a voyage, a former fifty-gun man-of-war HMS *Grampus* was converted into a hospital ship and moored off Greenwich Reach where the seamen could be treated. Replaced in 1831 by the larger ninety-eight-gun *Dreadnought*, and then by the even larger 120-gun man-of-war the *Caledonia*, the vessel renamed *Dreadnought*. All three Infirmary ships, serving the nation well in times of war, had all been held in high regard by residents of Greenwich.

Following the closure of the Royal Naval Hospital in 1869, the Seamen's Hospital Society leased the vacant infirmary from the Admiralty to administer medical and surgical care of merchant seamen and fishermen, the building taking the name Dreadnought Seamen's Hospital. The ship continued to function as an infirmary

treating sailors with tropical diseases, and then as isolation accommodation during the smallpox academic of 1871. During the late nineteenth and early twentieth centuries, the society allowed the shore-based hospital to treat local residents of Greenwich, Deptford and Blackheath alongside merchant seamen. It sustained damage through bombing during the Second World War, and after repaired the hospital became a specialist unit of the National Health Service.

As with many other small local hospitals, through National Health Service cost-cutting measures, the Dreadnought closed in 1986. The old Regency-period building then stood empty for more than ten years before conversion into the University of Greenwich students' library. Currently undergoing a complete refurbishment, the Dreadnought building will provide a new home for the Student Union and centre for academic services.

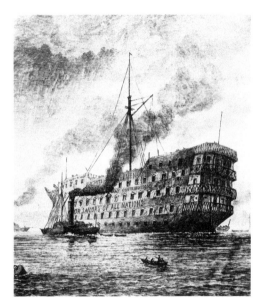

Right: Dreadnaught hospital ship leaving moorings at Greenwich in 1874.

Below: Dreadnought Seaman's Hospital, Romney Road, mid-1900s.

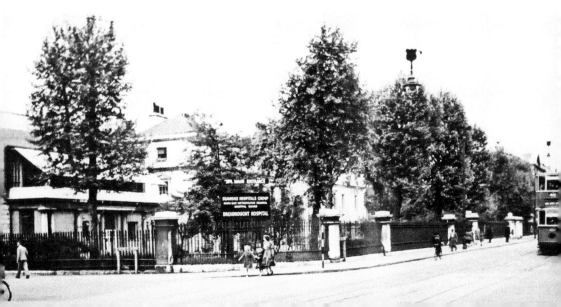

John Harrison

For fans of TV sitcom *Only Fools and Horses*, the story of a family of south-east London wheeler-dealer traders, the Trotters, they will all remember one of the most brilliantly written episodes by John Sullivan, 'Time on Our Hands', when Del 'Boy' Trotter finally became a millionaire after discovering and auctioning an old pocket watch that turned out to be the eighteenth-century nautical watchmaker John Harrison's 'lesser watch'. The storyline was based upon Harrison's semi-mythical timepiece, a design of which existed though the watch itself may never have been made. Although the actual nautical chronometers designed by Harrison revolutionised navigation at sea, he made far less money from his life's work than Del 'Boy' made from selling the nautical timepiece.

Harrison journeyed to London from Yorkshire seeking support, and the rewards promised by the 1714 Longitude Act, for creating a timepiece to aid navigators precisely plot a vessel's position of longitude at sea. Warmly greeted by Edmond Halley at Greenwich Royal Observatory, the Astronomer Royal and a Commissioner of Longitude felt capably unable to judge Harrison's work and sent him to meet with clockmaker George Graham. So impressed was Graham with Harrison's design, the clockmaker became his advisor and financial backer. For the next few years Harrison continued developing his first marine timekeeper, known as H1. After tests carried out on the Humber, Harrison returned to London with his chronometer for sea trials aboard HMS *Centurion* in May 1736. Although the marine clock did not work as well as Harrison hoped during the early part of the voyage to Lisbon, by the time the ship reached port H1 was working more accurately. On the return voyage aboard HMS *Orford*, Harrison saved the ship from foundering on rocks at the Lizard Peninsula, Cornwall, after convincing the officers his chronometer readings showed the vessel to be 60 miles off course. Following the successful sea trials, the Commissioners of Longitude agreed to pay Harrison £500 to build an improved marine timepiece. Harrison designed and made several updated versions of his chronometer – H2, H3 and H4. Continuously at odds with commissioners over payments they owed, Harrison was eventually financially rewarded by Parliament for services to the nation.

Although John Harrison's marine timekeepers were the most important ships chronometers ever made, they were kept in storage at the Royal Observatory until rediscovered after the First World War by retired naval officer Lieutenant Commander Rupert T. Gould, and after restoration were placed on permanent display. Harrison's 'lesser watch', if it exists, has still to be found. The reproduction prop watch used in the 1996 episode also went missing after being stolen from the Only Fools and Horses Museum, with a £1,000 reward offered for its safe return.

Jumbo

Designed by engineer George Livesey and erected on Greenwich Marsh in 1886, the Greenwich Gasholder, affectionately once known as 'Jumbo', has been under threat of demolition since the East Greenwich Gasworks was decommissioned during the 1990s. Officially known as Gas Holder No. 1, it was the largest gasometer in the world when built, with a capacity of 8,600,000 cubic feet. Newspaper articles nicknamed the huge structure 'Jumbo' and it dominated the industrial landscape of Greenwich. The *Kentish Mercury* reported an even larger gasometer was to be built next to 'Jumbo', with a capacity of 12,200,000 cubic feet. 'Jumbo' suffered damage from the Silvertown

Greenwich Gasometer, 'Jumbo', 2017, under threat of demolition.

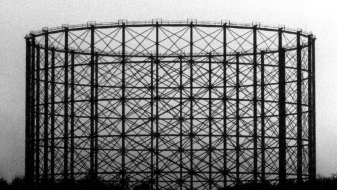

explosion of 1917, as well as during the Second World War, when bombs targeting riverside industries fell across the east of Greenwich. In 1979, a bomb planted by the IRA exploded adjacent to both gasometers, seriously damaging the larger structure, which was later demolished during the 1980s.

With Greenwich Marsh coming under large-scale redevelopment, Historic England decided the iconic gasometer did not meet the specified criteria for listing and Greenwich Council approved plans for the site owner, SGN (Scotia Gas Network), to demolish 'Jumbo'. Although other gasholders have been saved and transformed into modern residential buildings, commercial spaces, or exhibition and leisure facilities, if local industrial heritage groups are unsuccessful in saving 'Jumbo', Greenwich will lose its most recognisable historic industrial constructions.

Joseph René Bellot

The French-born Arctic explorer Joseph René Bellot was commemorated by the building of a tall red-granite memorial on the Thames riverside esplanade and the naming of a thoroughfare in East Greenwich, Bellot Street, where one of my friends lived. Neither of us, when youngsters, were aware how this street acquired the name; it was not until much later when I discovered both the street and memorial had been dedicated to the nineteenth-century naval explorer. A graduate of the École Navale, French Naval Academy, Bellot was wounded in action during an Anglo-French attack on the port of Tramatave, Madagascar, over rights of trade, Bellot receiving the Knight of Legion Honour in 1845, the same year explorer Sir John Franklin went missing during an Arctic expedition. Over the following five years, several attempted searches to locate Franklin's party, who were all presumed dead, proved unsuccessful. Bellot wrote to Lady Franklin offering his sympathy and volunteered his services to join a forthcoming search for her husband. Bellot joined the search vessel *Prince Albert*, under the command of Canadian fur trader William Kennedy, and although unsuccessful in locating Franklin, the Frenchman rescued Kennedy and a shore party after the *Prince Albert* was carried 50 miles away from their location by drifting ice. In 1852, recently promoted to the rank of lieutenant, Bellot sailed on his second expedition to the Arctic under the command of Captain Edward Inglefield aboard the *Phoenix*. While wintering at Beechy Island, Bellot, with two crew members from the *Phoenix*, set out across the ice to deliver messages to another search vessel moored in Wellington Channel. Suddenly, the ice began to break up, and as all three men drifted away from the shore Bellot fell through the ice into the freezing cold water and died.

Bellot's devotion to duty brought much admiration from those he served under and sailed with. The Royal Geographical Society Committee raised £2,000 after Bellot's tragic death for the commissioning of a granite obelisk in his memory, unveiled at Greenwich in 1855, the remaining funds going towards supporting Bellot's five sisters.

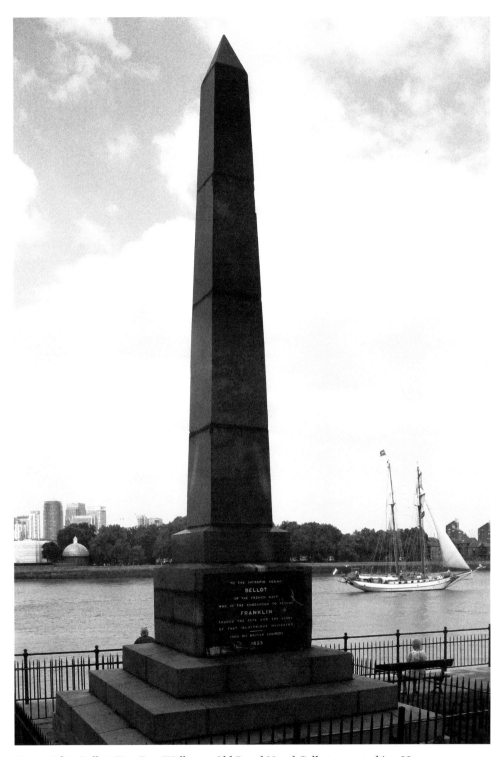

Memorial to Bellot, Five Foot Walkway, Old Royal Naval College, erected in 1885.

Kidd the Pirate

One of my favourite places to visit when I was a child was the clipper *Cutty Sark*, where, back in 1964, I saw Johnny Kidd and the Pirates, a popular 1960s rock 'n' roll group, posing for promotional photographs on the ship – Johnny Kid wearing an eye patch and wielding a cutlass, the rest of the band dressed in pirate attire. Lead singer Johnny Kidd styled himself on the mid-seventeenth-century privateer and pirate Captain William Kidd, who amassed a great fortune through his privateering exploits at sea, a proportion of which contributed towards paying for the building of the Royal Hospital at Greenwich. William Kidd, born at Dundee in 1654, journeyed to the Americas when a young man where it is believed he was taken on as a seaman's apprentice aboard a pirate ship. By 1689, Kidd was serving aboard a vessel sailing the Caribbean, taking command of the ship when the crew mutinied. Kidd befriended several prominent colonial governors who secured his services to raid and loot French held ports and attack their treasures ships, the proceeds making Kidd and his employers extremely wealthy men. Sailing with a letter of marque, a government licence signed by William III, Kidd acted as a privateer hunting down pirates and confiscating their treasures, the booty divided between Kidd and members of Britain's nobility who funded the venture. After purchasing the *Adventure Galley*, built and launched at Deptford in 1695, Kidd and his personally selected crew sailed downriver towards Greenwich, where, either by mistake or purpose, they failed to salute the king's yacht, as was the custom. The yacht fired a shot to signal Kidd's vessel to show respect, however the crew turned their backs towards the yacht and began slapping their buttocks in reply.

First sailing to America, then to the Cape of Good Hope, Kidd sailed his ship thousands of miles across the Atlantic and into the Indian Oceans with little reward. To recoup some of the investors' funds Kidd began attacking legitimate merchant vessels, sailing under foreign flags, his backers, powerful and influential men, turning a blind eye towards what could be considered acts of piracy, justifying Kidd's action by claiming the ships were sailing with French passes – Britain was at war with France at the time. Although a ship's captain was allowed take whatever action necessary to keep the crew in line, apart from murder, during one voyage Kidd killed a crewmember during an act of mutiny. When Kidd's privateering activities began

to cause embarrassment for the British government and its colonies overseas, Kidd was arrested and returned to England to stand trial. Found guilty of murder and five indictments of piracy, important evidence supporting Kidd's privateer actions withheld during proceedings, Kidd was sentenced to death and hung at Execution Dock, Wapping, on 23 May 1701.

After his death, Kidd's estate, along with a hoard of confiscated treasure, was sold at auction. A total of £6,472 of the proceeds, worth around £1.5 million today, donated to the Royal Hospital.

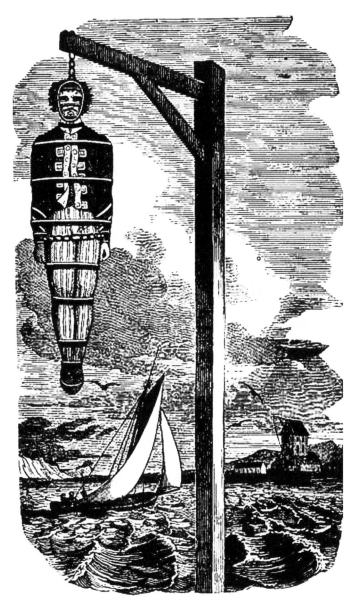

Captain Kidd, gibbeted after being hanged, at Execution Dock. (From *The Pirates Own Book*, Charles Ellms, 1837)

L

Lovell's

On meeting up with friends at dusk during the 1960s, a time when coal colliers tied up at Lovell's Wharf, as a dare we would traverse the dock lines securing the ship to the shore, clamber aboard, and then once on deck climb as high as we could up the pyramid-shaped tarpaulin covering the hold, suspended at its centre by a derrick boom, before being discovered and chased off by a member of the crew. At one time our stretch of the Thames would have been crowded with all types of vessels of various size, sailing back and forth along the tidal waterway or loading and offloading cargo at riverside wharfs and jetties. Originally known as Greenwich Wharf where coal from the north-east was offloaded, during the 1920s Shaw Lovell & Co. took over the lease for dealing in shipments of non-ferrous metals, the wharf changing its name to Lovell's. By the late 1980s, the river frontage came under intense redevelopment as long-standing commercial industries began to close down. After Lovell's moved out, two large cranes – Scotch Derricks, of national industrial importance – were removed without planning approval and the iconic, high, brick-built boundary wall was knocked down. While groundwork's were taking place on-site the remains of

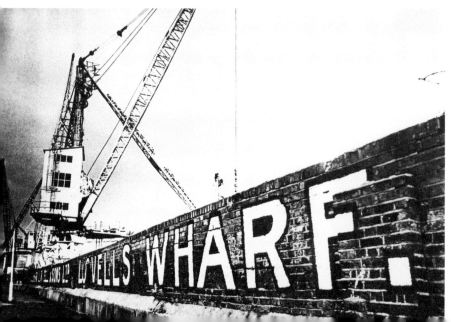

The famous Lovell's Wharf wall and Scotch Derricks before demolition in 2000.

a twelfth-century tidal mill were discovered, preserved in peat deposits – possibly the first industrial structure erected in East Greenwich and the earliest tidal mill discovered so far in London.

Lodge in the Park

As a frequent visitor to Greenwich Park, one building I often passed at Blackheath Gate was the Keeper of the Park's Lodge, a mock Tudor-style cottage erected in 1852 to the designs of architect John Phipps. The building replaced a seventeenth-century keeper's lodge, demolished in 1853, that was located towards the centre of the park, close to Queen Elizabeth's Oak. Greenwich park keeper Mr A. D. Webster, resident of the new lodge during the late 1800s, wrote a comprehensive history of Greenwich Park, published in 1902, lamenting in the passing of the old lodge, occupied by a succession of park keepers until the building fell out of use.

The Ranger's Lodge, Blackheath Gate, late 1800s.

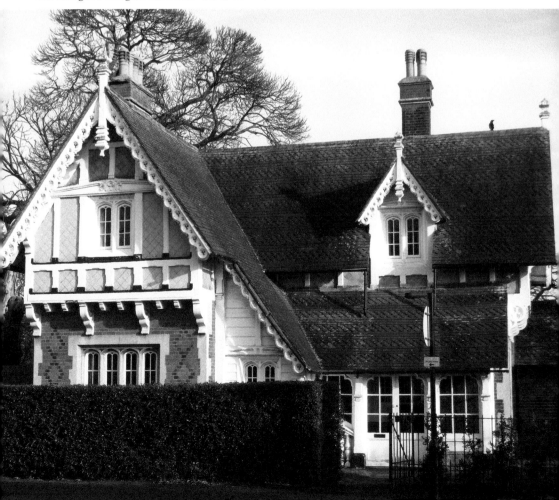

The new lodge, known also as the Ranger's Lodge, and at one time the Deerkeeper's Lodge, as it backed onto the deer park, was refurbished in the late 2000s for rental as a private dwelling. Each April since 1981 runners have set off from outside the lodge, me included in 2015, at the start of the London Marathon.

London Olympics

Although Greenwich was known as the starting place of the London Marathon, during the 2012 London Olympics and Paralympics athletes competing in the marathon started and finished at the Olympic Park, Stratford. Although the marathon took place north of the river, Greenwich was chosen as a venue to host the Olympic and Paralympics equestrian and dressage events at Greenwich Park, south of the Queen's House, close to the site of Henry VIII's tilt yard and joust arena at Greenwich Palace.

Other Olympic and Paralympics events with historic associations to the Royal Borough of Greenwich included shooting, the range located adjacent to the Royal Academy, Woolwich Common, where spectacular Royal Artillery manoeuvres and pageants once took place during eighteenth and nineteenth centuries, and on the opposite side of the common, close to Shooters Hill, archery competitions were held, close to where archers practised during medieval times.

Main entrance to the London Olympics 2012. Equestrian events, Greenwich Park.

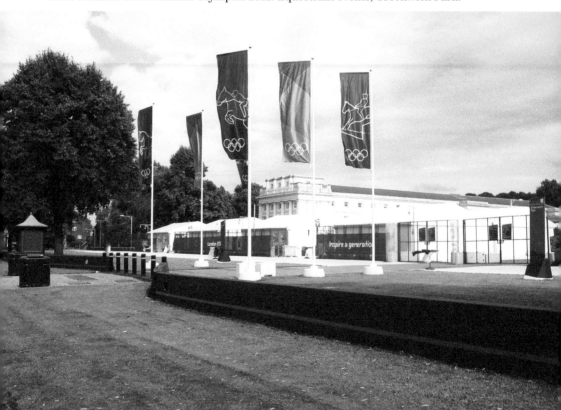

M

Motherstone Fountain

Towards the centre of Greenwich Park, away from the more popular tourist destinations, you will find a large stone-built water fountain closely resembling a Neolithic monument.

 Although ancient in appearance, the fountain, formed using Preseli bluestone, the same type of stone that made up the inner circle of Stonehenge, was constructed during the mid-1800s. Known by pagan worshipers as the Motherstone, or Goddess Stone, the fountain, once fed from a natural spring through lead pipes, is no longer in use as the water became unsafe to drink. When passing by the fountain, on occasion, visitors may discover the stone bowl filled with water, brought from Glastonbury Challis Well, or flowers, crystals and written spells left by local pagans.

The Motherstone Fountain at the end of Lovers Walk, mid-1800s.

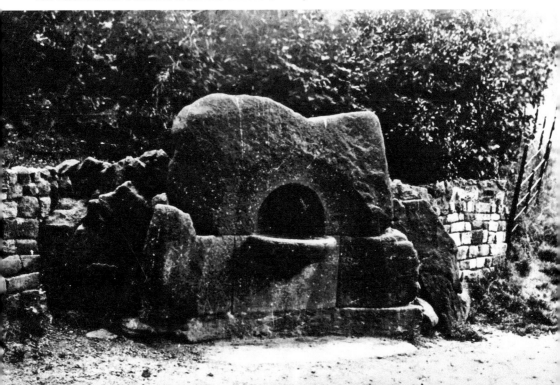

Markets

Before supermarkets became commonplace on the main high street, people of Greenwich bought goods from the local grocer, butcher, baker and fishmonger, and before this markets supplied a majority of the produce a local resident required. Since at least the medieval period various markets were held around the town's centre, and then after the Royal Charter Market was assigned to the Commissioners of Greenwich Hospital in December 1700 for a 1,000-year lease, the main market relocated from the grounds of the hospital to the Medieval Quarter.

In 1831, the present market would have been surrounded by courtyards, lanes and narrow alleyways, where many of the poorest of Greenwich inhabitants lived. Purchased by the commissioners of the hospital, the medieval buildings were demolished and the surveyor, Joseph Kay, transformed the whole area, erecting elegantly designed properties encompassing the market square, Turnpin Lane retaining the medieval street line through the market.

Although a majority of the market interior was refurbished during the mid-1900s, due to a rise in the number of high street supermarkets offering a variety of consumables and a change in local by-laws, traders selling traditional market fair

Below left: Nelson Road entrance to Greenwich Market, erected during the mid-1800s.

Below right: Turnpin Lane, leading to the market from Greenwich Church Street.

were replaced by traders dealing in crafts, collectables, fine art and antiques, the markets stalls surrounded by boutique shops, fine art galleries, restaurants and wine bars.

Mills

When Robinson's Flour Mill at Deptford Creek caught fire during the 1970s, the second in the nineteenth-century mill's history, I remember watching the huge cloud of black smoke drifting across the sky out towards the river as the historic building went up in flames. One of the only two surviving working flour mills on the creek, when the remains of Robinson's Mill was demolished it left Mumford's the last mill standing.

 Both Robinson's and Mumford's were built during the late 1800s, on a site where timber tidal mills had existed since before the Norman Conquest. The grain milling industry went through a period of radical change during the Industrial Revolution, when traditional grinding stone milling powered by tides was superseded by steam-powered steel rollers. Mumford's Mill closed in 1968 and the listed building was converted into residential apartments. To the east of Deptford Creek, on the heights of Blackheath, there were at least three windmills erected during the 1700s, one mill powering a wood lathe. After the introduction of steam-powered milling, windmills soon became redundant and the Blackheath mills were all dismantled.

Below left: Mumford's flour mill, Deptford Creek, early 1900s.

Below right: Blackheath windmills, close to Whitfield's Mount, *c.* 1815.

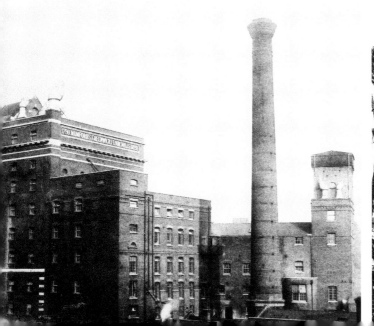

Nelson

Prior to the closure of the Royal Naval College in 1998, there were very few occasions when residents of Greenwich were able to enter the historic grounds to visit the impressively grand seventeenth-century buildings. My only opportunity to visit the college before it opened to the public came during the early 1970s, when the darts team I played for at the Star and Garter public house were invited to compete against a naval team – beer and curry included. Non-naval personnel had an opportunity to visit the Royal Naval College as guests when attending the annual Trafalgar Night dinner celebrations held in the Panted Hall to commemorate Nelson's victory over the combined fleets of the French and Spanish on 21 October 1805.

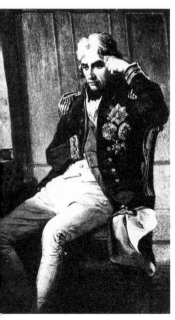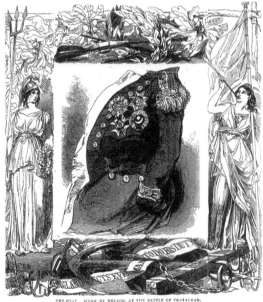

THE COAT WORN BY NELSON, AT THE BATTLE OF TRAFALGAR.

THE W·ISTCOAT.

Above left: Admiral Horatio Lord Nelson aboard *Victory* before the Battle of Trafalgar.

Above right: Tunic and waistcoat worn by Nelson when shot aboard *Victory* at the height of battle.

The body of Vice Admiral Lord Nelson, shot on deck of HMS *Victory* by a French sniper during the battle, was transported upriver to Greenwich Royal Hospital on Christmas Eve in 1805 for lying-in-state under the Painted Hall's magnificent mural ceiling.

During his naval lifetime, Lord Horatio Nelson often visited the Royal Hospital and infirmary, convalescing after losing an arm at the Battle of Santa Cruz de Tenerife in 1797. To honour Nelson, various places in Greenwich were named after the famous Admiral and his naval exploits, such as Nelson Road and Trafalgar Road, and the public houses Trafalgar Tavern, Lord Nelson and Admiral Hardy.

The bloodstained waistcoat, tunic, breeches and stockings worn by Nelson when he was fatally wounded were purchased by Prince Albert for display in the Painted Hall, before being moved to the newly opened National Maritime Museum in 1937, where they are now exhibited in the museum's Nelson Gallery.

National Maritime Museum

One of my ancestors, William Robinson, who was born at Woolwich in 1806, a year after the Battle of Trafalgar, was employed as a drill instructor at the Greenwich Hospital School, where children from seafaring backgrounds were boarded and educated, including two of William's sons, John and William Jr. Hospital schoolboys were expected to join either the Royal Navy or Royal Marines on completion of their education, and when girls were enrolled they were educated and prepared for employment in domestic service. On relocation of the Royal Hospital School to Holbrook, Suffolk, the impressive classical-style buildings were obtained through the National Maritime Act of 1934 for conversion to a maritime museum.

Marine artefacts and artworks were transferred from the Royal Naval College opposite, and on completion the museum was officially opened to the public in 1937. One of the most popular displays my friends and I would go to see was a huge glass-encased scale model of the Battle of Trafalgar, where English warships, guns blazing, the cannon smoke provided by stuck on balls of cotton wool, advanced upon the French and Spanish vessels, several appearing to be on fire and sinking, the clouds of smoke made from more cotton wool. At the centre of the engagement HMS *Victory*, mast broken and sails torn, was in broadside action against the French ship *Redoutable*, the famous *Téméraire* speeding to aid Lord Nelson's flagship.

In 1999, the main galleries were redesigned and on completion the new glass-roofed Neptune Gallery was unveiled. The Queen's House was restored and refurnished in 2001 as a place of royal residence, and in 2011 a new wing was opened that was dedicated to Sammy Ofer, an Israeli shipping tycoon who donated £20 million towards the £35 million expansion project. Although the Battle of Trafalgar model has long since gone, many scale model ships have been brought out of storage for display in four new maritime exploration galleries.

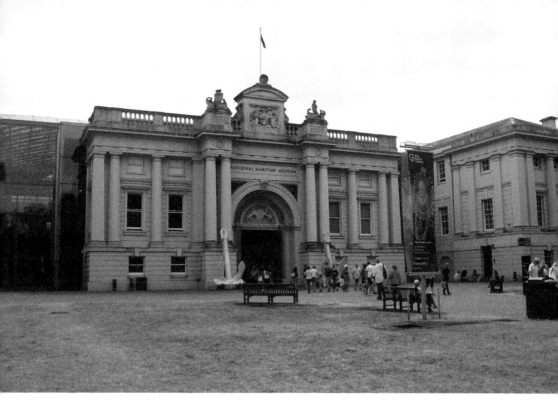

Above: Main entrance to the National Maritime Museum, Romney Road.

Below: Scale model of the Battle of Trafalgar, made for an exhibition in 1840, before being relocated to the museum.

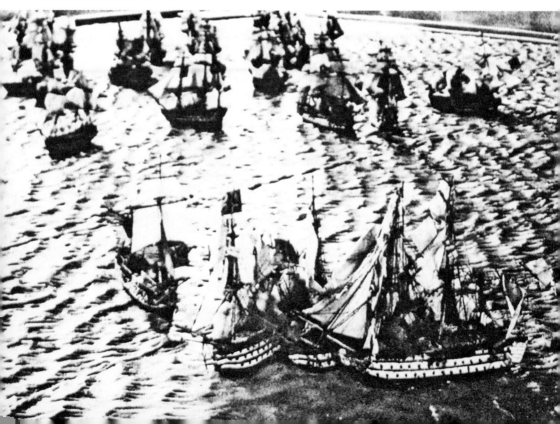

O

Observatory

Completed in 1676, further additions were added to the observatory for housing various telescopes, and in 1833 a Time Ball was installed on top of the front left-hand turret, the ball rising and falling daily at 1 p.m., a signal for setting marine chronometers of ships on the Thames. After the Royal Observatory relocated to Herstmonceaux, Sussex, in 1957, due to the increasing light pollution in London, the Greenwich buildings were opened as a museum of astronomy, navigation and timekeeping. In May 2007, the Peter Harrison Planetarium opened, the only functioning planetarium in London, named after the foundation providing funding to build the centrepiece of the Royal Observatory's 'Time and Space' project.

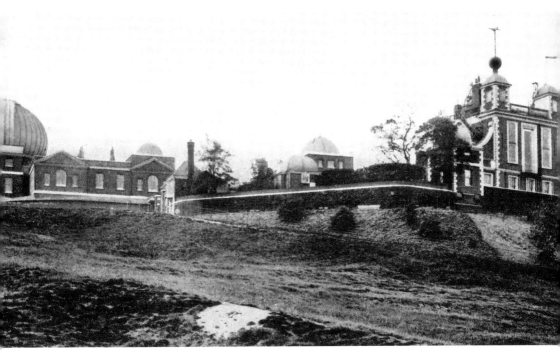

The Royal Observatory, early 1900s, erected on the site of Greenwich Castle.

Old Royal Naval College

Up until the beginning of the twenty-first century, the Royal Naval College buildings, originally the hospital for maritime pensioners, had been used for almost 150 years as an educational facility and training establishment for naval officers, housing the former Naval College at Portsmouth and the School of Naval Architecture and Marine engineering from South Kensington. Naval officers from all parts of the globe were educated at the Royal Naval College learning various naval sciences, administrative and staffing policies, and strategies of seaborne warfare.

Through the Second World War over 27,000 Royal Navy officers, including 8,000 WRNS, were trained at the college. In 1959, the Royal Navy's nuclear science and technology department moved to the Greenwich site, installing a nuclear reactor named Jason within the King William building, one of very few reactors operating in a densely populated area. After the Royal Navy left the magnificent Royal Naval College in 1998, the grounds were opened to the public and the University of Greenwich and Trinity School of Music took up residence in various former college buildings.

Old Royal Naval College, King William Quarter and Queen Mary Quarter colonnade walk.

Odo

One historic date above all others children remembered when I attended school was the year 1066, when King Harold was struck in the eye by an arrow and killed at the Battle of Hastings. After William the Conqueror's famous victory, high-ranking Norman barons were appointed to important places of office. William's half-brother, Odo of Bayeux, a bishop of war and second in power to the newly crowned king, granted the position Earl of Kent and tenant in chief at the manor of Greenwich. It is believed Odo may have been responsible for commissioning the Bayeux Tapestry, the pictorial record of the invasion possibly made in England by Anglo-Saxon embroiderers towards the end of the eleventh century. Around this time a grange was built at Greenwich, later known as Old Court, from where the manor was administered. Odo became a trusted royal minister and served as regent of England on occasions when William returned to Normandy, the bishop commanding the king's forces against Anglo-Saxon uprisings and rebellions. When Odo fell out of favour with William, accused of oppressive misgovernment and attempting to purchase the papacy, Odo was imprisoned and his landholdings, including the manor of Greenwich, were seized. When William I died in 1087, following Odo's release from captivity the bishop led an unsuccessful rebellion against William's successor, his third son William Rufus. Exiled to Normandy, Odo joined the First Crusade to the Holy Land, but died en route in 1097 and was buried at Palermo Cathedral, Sicily.

Penn's Marine Engines

If you mentioned the name John Penn to visitors of Greenwich today, or even ask some residents if they recognised the name, it is doubtful many would. During the mid-1800s, however, the name John Penn was internationally known as the leading builder of the most technologically advanced marine engines in the world. Born in Greenwich in 1805, John Penn was the son of Devonshire millwright and engineer John Penn Snr, who established an engineering business to the south of Blackheath Road near Deptford Bridge. Producing agricultural machinery, when Penn's son entered into the family business he began designing and building new types of steam

John Penn & Son's workshop, Greenwich.

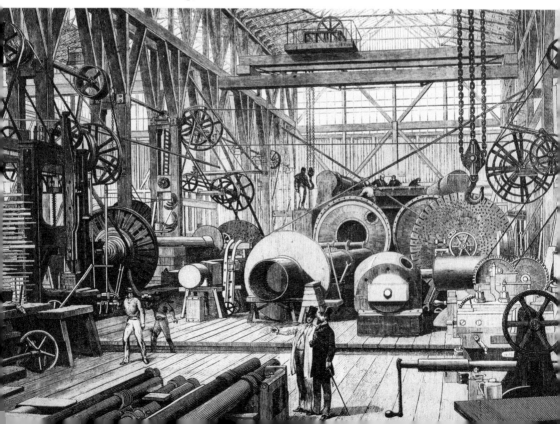

engines. After inheriting the business, Penn moved engineering production into building steam marine engines, a time when ships were turning from sail power towards steam power.

Penn's first marine steam beam engines were fitted into the paddle steamers *Ipswich* and *Suffolk*, and after perfecting the design of Joseph Maudslay's oscillating engine, Penn developed a compact trunk engine for driving screw propeller warships, with the first fitted to the Royal Navy vessel HMS *Encounter* in 1846. Just under ten years after launching, the owners of Isambard Kingdom Brunel's SS *Great Britain* replaced the ship's original engines with lighter and more compact engines built at Penn's engineering works. By the time of John Penn's death, the engineering works had fitted engines into over 700 vessels, including riverboats, ferries, gunboats and battleships. Although the works carried on producing engines under the ownership of Penn's two sons, the company amalgamated with Thames Ironworks in 1899 and by the early twentieth century the company had closed and the works demolished. Little remains to remind people of one of Greenwich's most important industrialists apart from the existing John Penn Road, which ran adjacent to the workshop, and the almshouses built in his memory on Greenwich South Street.

Peninsula

Up until the end of the twentieth century, Greenwich Peninsula was a large expanse of former marshland occupied by various light and heavy industries, manufacturers, boat and ship builders, a place offering plenty of employment for many Greenwich residents, including several of my ancestors. After a majority of the commercial

Greenwich Peninsula viewed from the main arterial road leading towards Blackwall Tunnel.

Modern apartments and town houses that are spreading outwards across the Peninsula.

industries fell into decline, a regeneration plan set out to make the marsh not only a focal point for the millennium celebration in 2000, but also the centre of an emerging modern district, Greenwich Peninsula. Following the celebrations, almost all of what many people considered a grim and grimy area of industrial Greenwich was demolished and gradually replaced by fashionable high-rise residential buildings, contemporary workplaces, luxury hotels, sports venues, exhibition amenities, restaurants and bars.

Over time the regeneration programme will undoubtedly eliminate all reminders of the marsh's important industrial heritage.

Q

Queen's Oak

According to the first edition of the nineteenth-century Ordnance Survey map, the Queen's Oak in Greenwich Park, believed to date from the twelfth century, is described as a sweet chestnut; however, it has since been indentified as an English oak.

Finding fame through legends dating to the Tudor period, the tree, around 400 years old at the time, was said to have offered shelter to Elizabeth I, who rode out from Greenwich Palace to take refreshment under its leafy canopy. At the base of the same tree her father, Henry VIII, and her mother, Anne Boleyn, were said

Queen's Oak at the centre of Greenwich Park, late 1800s.

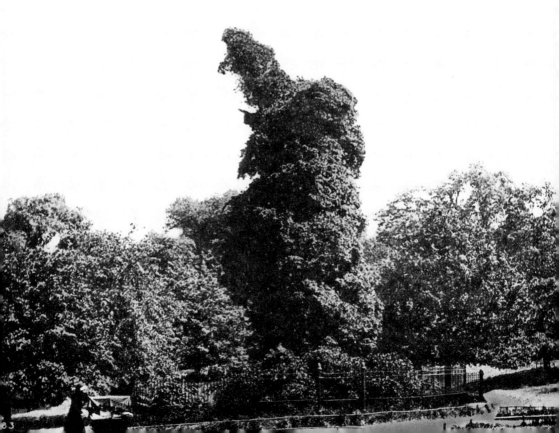

HISTORY OF GREENWICH PARK;
OR,
The Lay of the Old Hollow Tree.

They call me the Old Hollow Tree,
 In truth it so appears,
For I have been a hollow tree,
 Above three hundred years.

A terror oft my name has been
 To schoolboys and to thieves,
Who chestnuts have been knocking down,
 Or damaging the trees.

For my old trunk is made into
 A prison with a door,
And many times has been confin'd
 Young urchins half a score.

And many are the darksome deeds
 That I could tell of old,
Of robberies and murders too,
 Would make the blood run cold.

While I was standing here, about
 Eight hundred years ago,
A dreadful murder did take place,
 Within the town below.

The Danes from Canterbury brought
 The Archbishop Alphage,
Who they most cruelly did kill,
 And burnt the town with rage.

And many are the battles too,
 And many are the slain,
That I have seen interr'd beneath
 The mounds on yonder plain.

For then the ground where I now stand,
 And Blackheath was all one,
No wall, or fence, or park was made,
 And I stood near alone.

In A.D. fourteen thirty-three,
 When the Sixth Henry reigned,
Humphrey, Duke of Gloucester, then
 A license first obtained ;

To fortify his manor-house,
 And join a park thereto,
Two hundred acres he enclosed,
 Of heath and orchards too.

The manor-house he did rebuild,
 And " Placence " it was nam'd,
Likewise a Tower upon a hill,
 Which history has fam'd.

But the Seventh Henry did enlarge
 The Palace, and reside
Himself and Royal Family,
 And kept his Court beside.

'Twas there in fourteen ninety-one
 Henry the Eighth was born,
And many things that I could tell,
 Not to his honour done.

(His first wife Katherine of Spain,
 Hath oft sat down and cried
Beneath my shade when she passed
 Alone at eventide.

His fourth wife, Ann of Cleves, poor soul,
 What fuss he made about her,
They passed by me in solemn pomp*
 And in a month did scout her).

And there in fifteen thirty-three,
 Elizabeth was born,
And often have I witnessed
 Her gambols on the lawn.

When James the First came to the Park,
 And saw the fence was poor,
He built a strong brick wall all round,
 To make it more secure.

But 'twas in Charles the Second's reign,
 In sixteen eighty-three,
The Park was formed and planted out
 With trees as now you see.

He built the Observatory,
 Where stood Duke Humphrey's Tower,
And Doctor Flamstead, then was made
 Royal Astronomer.

But I dare say that you are tir'd
 Of hearing me go on,
About the Park and other things
 That long ago were done.

I'll leave off now, but come again,
 You know my residence,
Near where the Keeper's House once stood,
 Within the garden fence.

For though my head is nearly bare,
 As you can plainly see,
Yet I may last for aught I know,
 Another century.

* Ann of Cleves came down Shooter's Hill at 12 o'clock, January 3rd, 1540, and alighted in a Tent of Cloth of Gold, prepared for her by the King's orders, on Blackheath, where the King met her, attended by a great number of the Nobility, Bishops, Heralds, &c., who conducted her through the Park, to his Palace, at Greenwich. He married her January 6th, 1540, but he soon had a divorce, and married Katherine Howard, August 8th, in the same year.

☞ A Spring Pump within forty yards of the tree.

Printed and Sold by E. W. POOK, " Kent Printing Office," 3, London Street, Greenwich.

Story of the Queen's Oak pamphlet, published late 1800s.

to have danced around together. The oak's hollow trunk was often used during the mid-seventeenth century to detain park criminals and deer poachers locked inside behind a heavy wooden door.

Although the oak died during the nineteenth century, the tree was held up by twisted branches of ivy growing up its trunk, and for many of my friends and me, who once played in Greenwich Park when young, we were fortunate to have seen one of the most famous Greenwich landmarks standing tall before it was brought down during a torrential rain storm in 1991. The remains of the ancient tree were left where it fell and an oak sapling was planted in its place close by.

Queen's House

Commissioned in 1616 by Anne of Denmark, Queen Consort of Scotland and wife of King James, the Queen's House, designed by the Surveyor of the King's Works, Inigo Jones, is one of the architect's earliest commissions. Also going under the title 'the House of Delight', the building was completed during the reign of Charles I, under direction of Queen Henrietta Maria. According to official accounts, the foundations were laid out in 1616 at the site of a demolished roadway gatehouse. To retain the main road through Greenwich, the house was planned in two separate rectangles, each side connected by a bridge, similar in design to a house Jones had seen while travelling

Queen's House – The House of Delight, designed by Inigo Jones.

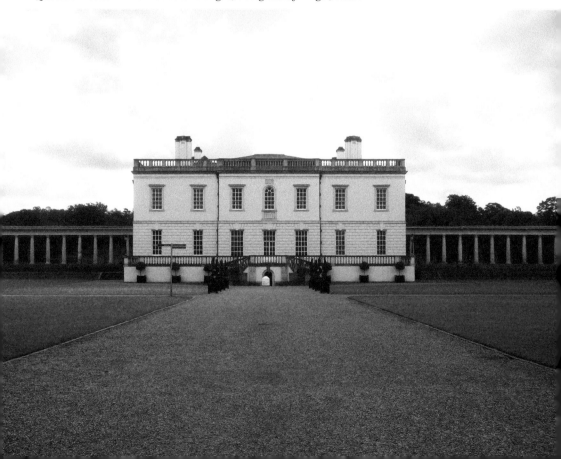

through Italy. Before the English Civil War, when the royal household resided at Greenwich Palace, Queen Henrietta Maria oversaw the building's completion, decoration and furnishing. Two more bridges were added each side of the first after Jones's death in 1652, and walls were later erected enclosing the upper storey, making two buildings into one but retaining the roadway below.

After the Restoration, the Queen's House became a royal grace and favour residence, and by the early eighteenth century the grand property had become home to the ranger of Greenwich Park. Donated by the Crown for use as a Royal Hospital School, a maritime education facility, the Queen's House and adjoining buildings later became home to the National Maritime Museum.

Quakers

Most weekday mornings, before I left home to go to school, I would have a bowl of Quaker Oats porridge for my breakfast. Little did I know at the time that my bowl of oats had connections to the founder of the Quaker State of Pennsylvania and

Quakers Friends Meeting House, Blackheath.

Greenwich Quakers, the Society of Friends. Quakerism first arrived in London during the mid-seventeenth century and meetings were held at various places throughout London, including Greenwich Palace. After the first gatherings in Greenwich, a Friends Meeting House was acquired on Deptford High Street in 1693 – Tsar Peter the Great attended meetings while studying shipbuilding at Deptford in 1698. It was at the Deptford Friends Meeting House where the tsar made the acquaintance of William Penn, the founder of the province of Pennsylvania. After the Parliamentarian victory over the Royalists, Quakers were continually persecuted for their beliefs and Penn was imprisoned in the Tower of London on several occasions. After the Restoration, Penn asked Charles II to grant him land in the Americas as payment of a loan the king owed Penn's father, Royal Navy Admiral and politician Sir William Penn, the land grant being the largest ever issued to an individual. Charles II named the province Pennsylvania, in memory of Sir William Penn. Penn's son became governor of the colony in 1682.

After the closure of the Deptford meeting house in the early 1900s, a new Society of Friends held meetings at Woolwich. By the mid-1960s, the congregation had outgrown its premises, and the meeting house was sold in 1964. After moving into temporary accommodation at Blackheath, a new meeting house was built on vacant land off Independents Road, close to Blackheath railway station, where Quakers continue to meet today.

Robinsons

Many of my ancestors, since at least the early 1800s, were born and raised in Greenwich. Most lived very quiet and predictable lives, never straying too far from home; however, one branch, the Robinsons, were different. They were forward thinkers with a taste for adventure.

The portrait of one, Edward Robinson, hung above the mantelpiece in our kitchen, and while young I would sit next to the open fire with my great-grandmother who would tell me stories about Edward's life as a policeman.

A carpenter by trade, Edward Robinson joined the police force in 1870 and was stationed at East Greenwich Police Station, Park Row. PC Robinson, Divisional Number R202, gained fame for capturing notorious murderer and cat burglar Charlie Peace when the Victorian villain attempted to evade capture after breaking

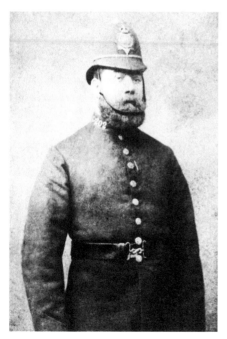

PC Edward Robinson, *c.* 1878.

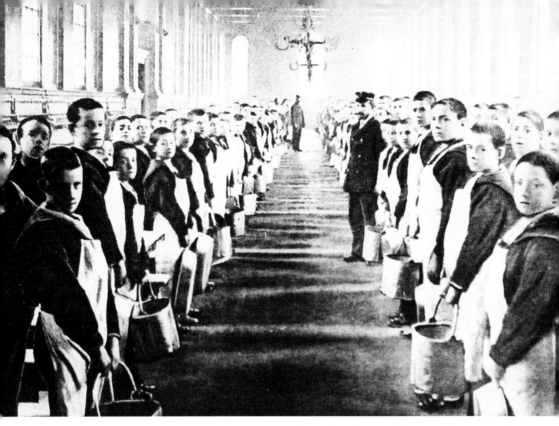

Royal Hospital School early 1900s. Here boys were educated and trained for a naval career, and girls in domestic service.

into a house at Blackheath. Although shot in the arm by the burglar, PC Robinson wrestled his adversary to the ground and knocked him out with the revolver. Many years later, when my father met and married my mother, it was discovered that Charlie Peace, who moved to London from Sheffield after committing two murders, was my great-grandmother's godfather, on my mother's side of the family. Peace, then living under an assumed name at Nunhead, and to all appearances a wealthy musician and inventor, befriended the family to keep up his cover of respectability. Peace was eventually hung for his crimes at Leeds Armley Prison and PC Robinson was promoted to Sergeant before being transferred to H Division, Whitechapel, when the hunt was on for Jack the Ripper. After resigning from the force, Robinson packed his bags and left England on a boat bound for Canada, intending to make a living in the outback. From Canada, Robinson then made his way down to the West Indies before returning home to Greenwich where he died in 1926. Buried at East Greenwich Pleasaunce, a cemetery usually reserved for naval personnel, including men who fought at the Battle of Trafalgar, Robinson was laid to rest among heroes.

Two of Edward's older brothers, William and John, attended Greenwich Hospital School for boy sailors. William fulfilled his military ambitions in 1856 by enlisted in the army and serving with the 75th Regiment, later to become the Gordon Highlanders, where he attained the rank of sergeant major. Posted to India, Robinson saw action during the Indian Mutiny at the Siege of Delhi and the Relief of Lucknow, receiving

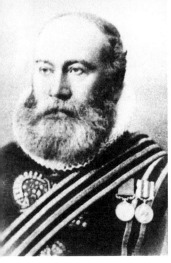
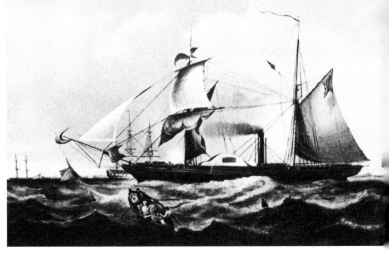

Above left: William Robinson, Yeoman of the Guard, *c.* 1887.

Above right: Joseph Robinson's ship, HMS *Cyclops*, launched in 1839.

the Indian Mutiny Medal with clasps. William married a British colonial girl, Julia Glenning, at Fort William, Calcutta, before being transferred to Gibraltar, then Hong Kong, the Cape of Good Hope, Ireland and the Channel Isles. In 1887, Robinson was appointed Yeoman of the Guard, serving as the official bodyguard to Queen Victoria.

On his retirement, William became a school board visitor (no doubt his military career served him well in keeping schoolchildren in line) and in the latter years of his life lived offsite as a Chelsea Pensioner.

Another of the Robinson brothers, Joseph, joined the Royal Navy, serving as an ordinary seaman, 2nd Class, aboard HMS *Cyclops*, a steam paddle frigate patrolling the waters of the Atlantic, Mediterranean, East Indies and China.

At the massacre of Christians by Mohammedan fanatics at the Ottoman town of Jeddah, Robinson's ship took aboard many of the town's survivors, before sinking the aggressor's armed boats and bombarding their shore batteries. Robinson's frigate later carried out much more peaceful duties assisting in laying telegraph cable between Newfoundland and Ireland, acting as the sounding vessel for the cable-laying ships HMS *Agamemnon* and USS *Niagara*. The subsea cable was developed and made at works in Greenwich.

Ranger's House

Before the Ranger's House was built, Andrew Snape, sergeant farrier to Charles II, erected stalls on a strip of wasteland in 1670 for grazing the king's horses on Blackheath, and by 1688 had constructed three houses at the site, one of which partly occupied an area where the Ranger's House stands today. Occupied by Admiral Francis Hosier, who made his fortune through trading ventures at sea, the seafarer made extensive alterations to the original building, converting the house into a splendid Georgian villa. After dying at sea without leaving a will, a long legal dispute ensued

between Hosier's wife and his mother's relations, until the lease was eventually sold to John Stanhope in 1740. On Stanhope's death in 1748, the house was passed on to his elder brother, the politician and diplomat Philip Dormer Stanhope, 4th Earl of Chesterfield, who named the property Chesterfield House. While in residence the earl made improvements to the house, including the addition of a bow-windowed gallery for entertaining guests. Sold in 1782 to Edward Hulse, high sheriff of Kent and deputy governor of the Hudson's Bay Company, the house later became a grace and favour residence for members of the royal household and then accommodation for the ranger of Greenwich Park, an honorary royal appointment.

Acquired by London County Council in the late 1800s, the Ranger's House served as a sports and social club before coming into the care of English Heritage for exhibiting traditional and contemporary art. In 2002, the Ranger's House became home to the magnificent Wernher Collection, works of art, silver, jewels, bronzes and porcelain, assembled by nineteenth-century German-born diamond mine entrepreneur Sir Julius Wernher, a respected member of the British establishment and one of the richest men in the United Kingdom.

Front façade of the Ranger's House, Chesterfield Walk.

Rowing Clubs

Living in close proximity to the Thames, a majority of Greenwich residents had a close affinity to the river, either through work or pleasure. One favourite pastime of energetic young men of Greenwich was rowing, a sport evolving from races between professional Thames watermen competing for prizes awarded by London guilds and livery companies. To the east of the Trafalgar Tavern, Corbett's Boat Yard hired out all types of rowing boats – for pleasure and competition. Rowing races took place over a long stretch of the river from Limehouse to Blackwall Point. In 1787, Curley Rowing Club, later renamed Curlew, took part in their first ever regatta on the Thames, off Greenwich, and from then onwards competition rowing became a popular sporting pastime and soon other clubs were forming up and down the river.

To accommodate an increase in membership during the mid-1800s, Curlew rented the Crown and Sceptre Inn as its headquarters, until forced to relocate to the Trafalgar Tavern when the inn was demolished in 1934. Another local rowing club, Stones, founded by workers of Stones Engineering Works, Deptford, was unable to secure headquarters at their riverside works and relocated to a public house, the Lord Clyde, renaming the club Clyde. Moving headquarters to the Globe public house brought another name change, but after the Globe was pulled down in 1938 the club moved from one meeting place to another, the enthusiasm of Globe's members keeping the club going. Eventually, permanent headquarters were found at Crane Street, Greenwich, the Trafalgar Rowing Centre, used by both Curlew and Globe.

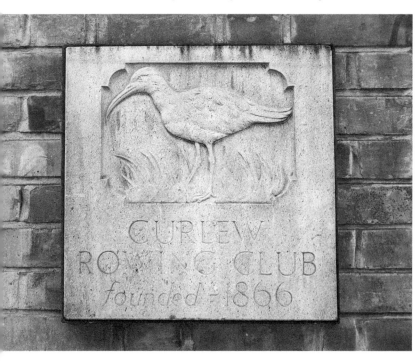

Curlew Rowing Club plaque, situated outside the Trafalgar Centre's entrance on Crane Street.

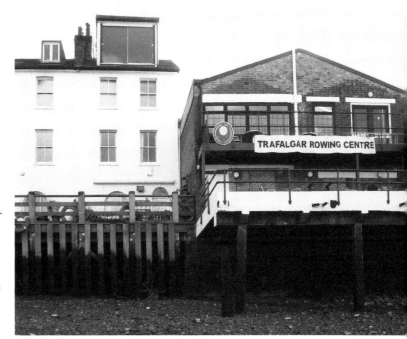

Right: Rear of Trafalgar Centre overlooking the Thames.

Below: Corbett's boat hire and pontoon at the site next to the current Trafalgar Rowing Centre, early 1900s.

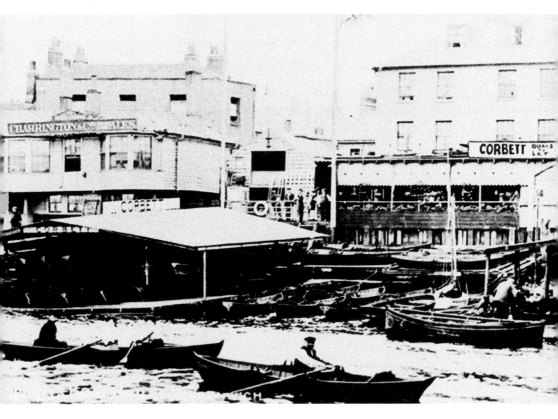

Stockwell Street

The historic medieval centre of Greenwich, once a warren of narrow streets and alleyways made up from ramshackle timber buildings, covered an area from south of the Thames Embankment to Stockwell Street, the north end of an old Roman road leading down from Blackheath to Greenwich. The street acquired the name Stockwell from the old Stock Well once used for drawing up water. After the 1960s-built John Humphries Computer Office was demolished prior to the construction of the £76 million University of Greenwich building, archaeologists excavating below ground level discovered field patterns and ditches dating back to the fourteenth century, and the remains of an eighteenth-century malthouse, the malt supplying local Greenwich brewers. Other finds included bottles, coins, ceramics and pieces of medieval pottery dating to a period when Stockwell Street was once lined on each side with picturesque brick and weather-boarded properties.

After many of Stockwell Street's historic buildings were damaged by bombs during the Second World War, rather than repair them a majority were knocked down. Only Spread Eagle Yard, a former seventeenth-century coaching inn, and a few adjoining properties were spared demolition.

Stockwell Street junction at Nevada Street, with original seventeenth-century buildings to the right.

Showtime

During the 1970s one of my favourite comedic actors, Max Wall, performed a one-man show, 'Aspects of Max Wall', at Greenwich Theatre, recapturing the humour of old-time music halls. At the end of the performance members of the audience, myself included, gave Max Wall a standing ovation. Acknowledged above all as a comedian, Max Wall was praised for his dramatic performances when appearing at Greenwich Theatre, starring in Samuel Beckett's *Krapp's Last Tape*, Shakespeare's *Twelfth Night*, Harold Pinter's *The Caretaker* and John Osborne's *The Entertainer*, portraying the tragic figure Charlie Rice, one of Wall's most memorable roles. Many of Max Wall's contemporaries performed at Greenwich during the late Victorian and early Edwardian periods, including singer-songwriter Arthur Lloyd, comedian Dan Leno,

Pamphlet promoting Morton's Model Theatre, early 1900s.

Crooms Hill entrance of Greenwich Theatre.

dancer and singer Kitty Fairdale and actress Ellen Terry. The theatres and music halls were packed by people travelling to Greenwich by riverboats, horse and carriages, trams and trains. On the corner of Crooms Hill and Nevada Street, the Rose and Crown public house occupies part of the site of a music hall bearing the same name, believed to have Elizabethan origins. Refurbished in 1871 and named Crowder's Music Hall (after the owner Charles Spencer Crowder), the public house was then erected directly adjacent to the theatre in 1888. After various changes of both ownership and name, in the early 1900s the main entrance on Nevada Street relocated to Crooms Hill and the theatre was renamed Hippodrome. When films became a more popular form of entertainment, in 1924 the theatre was converted into a cinema. Closing down when damaged by an incendiary bomb during the Second World War, the building faced the prospect of demolition until a successful campaign, supported by local actor and producer Ewan Hooper, secured its future. Reconstructed internally with a new entrance frontage on Crooms Hill, Greenwich Theatre reopened its doors to the public in 1969.

Other renowned Greenwich theatres, however, did not fare so well. Carlton Theatre, built in 1864 on London Street and converted into a cinema, was demolished to make way for the new Greenwich Town Hall building. Music halls (many attached to public houses), including the Royal Clarence Music Hall above the Admiral Hardy at Greenwich Market, soon fell out of favour as a place of live entertainment.

Shepherd Clock

At the top of Greenwich Park's Observatory Hill a long, steep path leading down towards Jubilee Avenue is where my friends and I, when adventurous schoolboys, would freewheel on our bikes to the bottom as fast as we could, then push them back up, timing our runs on the Shepherd Gate Clock to find out who was the fastest. Mounted on the outside of the observatory's boundary wall, the clock, one of the earliest examples of an electric timepiece, worked by means of a slave mechanism controlled through electric pulses transmitted by a master clock inside the observatory building. Constructed and installed by Charles Shepherd in 1852, the Gate Clock was the first to display Greenwich Mean Time to the public.

The Shepherd Gate Clock originally showed astronomical time, where the counting of twenty-four hours began at noon. The clock then changed to indicate Greenwich Mean Time, with the start of the twenty-four-hour day beginning at midnight. Visitors to the observatory can now check their own timepieces for accuracy against Shepherd's clock without the fear of cyclists speeding by, as rumble strips and anti-cycling barriers have now been installed on the steep gradient walkway.

Shepherd Gate Clock showing twenty-four hours, early 1900s.

Trinity Hospital

Only ever open to the public one day a year, in the late 1960s Britain's most popular heavyweight boxer, Henry Cooper, attended the Trinity Hospital Almshouse summer open day as the special guest – the main reason I entered the grounds for the very first time was to get Henry's autograph. Founded in 1613 by the Earl of Northampton, the hospital almshouse, the oldest building in the centre of Greenwich, provided accommodation for retired gentlemen. Erected on the site of Lumley House, this was once the home of Robert Dudley and Elizabeth I was a frequent visitor while in residence at the Palace of Placentia. The Grade II listed hospital was acquired by the Mercers' Company in 1621.

Accommodated in small furnished rooms, situated within a two-storey cloistered quadrangle courtyard, prospective residents had to meet a certain criteria to gain a place

Historic Trinity Hospital, Highbridge Wharf.

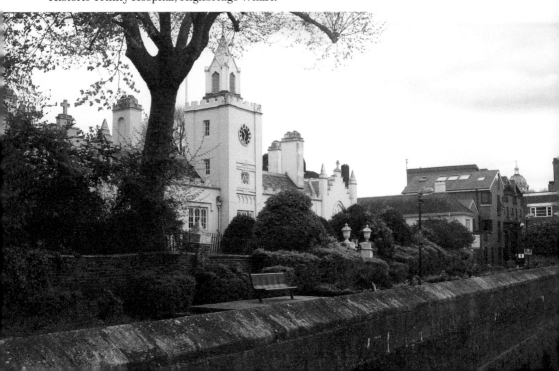

at the hospital: applicants were required to be at least fifty-six years old, able to recite the 'Lord's Prayer' without help, and be neither beggars or drunkards nor a 'whore hunter'!

Each Sunday a service was held for residents in the hospital's chapel, to the east of the square, where a splendid sixteenth-century Flemish window depicting the Crucifixion had been installed after rescued from a fire in another property owned by Henry Howard. The garden to the rear of the hospital consisted of assorted mature trees, including a mulberry, one of many planted during the reign of James I in expectation of harvesting silk for the proposed English silk industry. When new accommodation blocks were built in 2007 to the south of the hospital grounds, the Mercers' Company commissioned the design of two sundials, installed to mark the Greenwich Meridian Line passing through the grounds.

Tea Clippers

As most people know, whether a resident of Greenwich or a visitor, the maritime town is home to the world's most famous tea clipper, the *Cutty Sark*. Placed in dry dock during the same year I was born, 1954, I have always felt an affinity to this grand old ship. After surviving many voyages sailing into the inhospitable waters around the globe, the clipper almost came to grief in 2007 when the hull, stripped down while undergoing refurbishment, accidentally caught fire, the blaze caused by faulty electrical equipment. The fire aboard was not as severe as first feared and, on completion of the restoration, the *Cutty Sark* reopened to the public in April 2012.

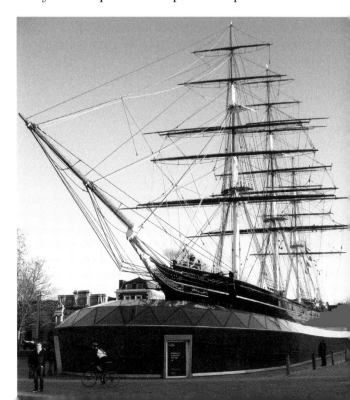

The most famous clipper in the world, *Cutty Sark*.

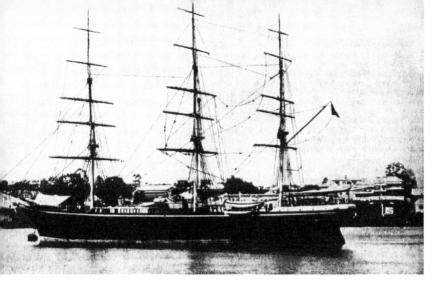

The clipper
Blackadder, built
and launched
a year after
her elder sister
Cutty Sark.

The faster of the
three sister ships,
Hallowe'en.

Commissioned in 1869 by Scotsman Jock 'Whitehat' Willis, a merchant seaman and trader, the *Cutty Sark*, built and launched on the Clyde, Scotland, had two sister ships: the *Blackadder* and *Hallowe'en*, constructed at Bay Wharf, Greenwich Marsh. Unlike *Cutty Sark*, a composite ship, wood clad on an iron frame, Willis commissioned both new clippers to be built totally in iron by Maudslay Son and Field, a relatively inexperienced iron shipbuilding company.

After its launch in February 1870, the metal mainmast and mizzenmast collapsed during *Blackadder's* maiden voyage to Shanghai. Although *Hallowe'en* fared better after its launch in June 1870, both vessels suffered various technical problems and sailing mishaps during their early voyages. It was said the *Hallowe'en* was the better ship to sail, rivalling the *Cutty Sark* for speed and beating the famous clipper

Thermopylae's sailing time on a return voyage from the China Sea laden with tea. After many profitable but long, hazardous voyages, both the *Hallowe'en* and then the *Blackadder* were wrecked at sea.

Trams and Trolleybuses to Motor Buses

The first London trams, horse-drawn vehicles running on metal rails, began operation in 1860, but it would not be for another twenty years before horse-drawn tramcars were running through the cobbled streets of Greenwich. After the formation of the Woolwich and Plumstead Tramway Company by an Act of Parliament in 1880, the company received the right to build a tramway from Woolwich to Plumstead.

Tram No. 70 en route along Greenwich Church Street, early 1900s.

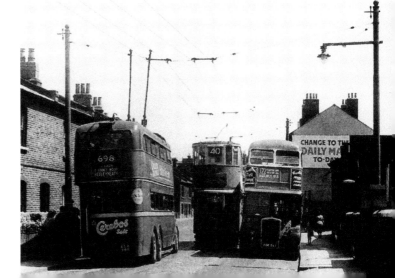

Trolleybus, tram and motor bus on Plumstead transit through the borough of Greenwich, mid-1900s.

When taken over by a local businessman in 1881, a new company was formed, the Woolwich and South-East London Tramways Company. The tramway was then extended between Woolwich and Greenwich, joining the end onto tracks of the London Tramways Company. Many of the horses pulling tramcars were stabled at Greenwich, at the site of the demolished Crowley House, where Greenwich Power Station was later erected to electrify London's tramways.

In 1904, London County Council took over running the city's transport system, replacing horse-drawn tramcars with electrified trams operating on the main highways through Greenwich for over almost fifty years. Although trolleybuses started to replace trams in 1935, using the same electrification system, the change was halted by the Second World War. At the end of hostilities trams were soon replaced by both trolley and motor buses, and as trams were taken out of service hundreds of people gathered on the streets to bid them farewell.

London's last tram, numbered the same as the year trams were retired, 1952, was driven from Woolwich to the tram scrapyard at Charlton by the mayor of Woolwich, a former horse-drawn tram driver. Although trams had gone, people continued travelling on trolleybuses, I remember clearly myself being taken on a trolleybus from Greenwich to Woolwich when my mother went shopping on a Saturday morning. Even though riding on a trolleybus became a thing of the past when taken out of service between 1959 and 1962, there are proposals to introduce modern trolleybuses back onto the streets of the Royal Borough of Greenwich.

One of the first Greenwich motor buses, Blackwall Lane.

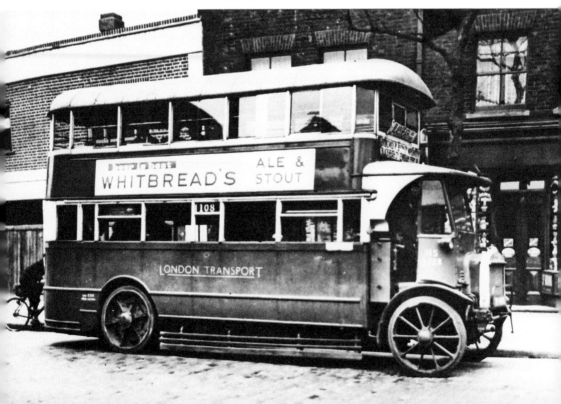

U

Union Workhouse

The old Union Workhouses played a significant part in my family's history. I was born in the building after it was converted to St Alfege's Hospital, and it was in this workhouse where my great-great-uncle PC Edward Robinson spent the last few years of his life, not because he was destitute, but as a well-respected resident cared for in the infirmary.

Robinson's mother worked at the Union Workhouse across the Thames from Greenwich at Poplar, where, at the time, an unmarried mother gave up her baby for adoption. The child was taken in by my great-grandmother, Edith Pearce, and cared for as one of her own. This was not an uncommon occurrence during the late 1800s and early 1900s, many illegitimate children growing up unaware they were adopted.

The first Greenwich Parish Workhouse opened in 1724 next to St Alphege's Church. The cost of keep for each inmate came to approximately £3 9s 4d per annum, equivalent to around £650 today. The inmates received three meals a day – breakfast, dinner and supper. Servings consisted of either bread and cheese, beef broth or porridge for breakfast; broth, puddings or rice for dinner; and bread and cheese for supper. A second workhouse opened in 1765 at Maidenstone Hill, West Greenwich, and by 1776, a third was in operation, housing up to 350 inmates. In 1839, inmates were transferred to other local parish workhouses, while a new workhouse was built at the junction of Woolwich Road and Vanbrugh Hill. Known as the Woolwich Road Workhouse and Vanbrugh Hill Infirmary, designed by R. P. Browne, the building was one of the earliest and most popular types of workhouse. Comprising of a two-storey

Nineteenth-century-built workhouse and infirmary Vanbrugh Hill.

entrance block and a three-storey main block, the workhouse included master's quarters, a dining room and chapel, and a range of dormitories for various classes of inmates, including one for women of ill repute. Workhouse discipline was extremely harsh and inmates, forced to work hard to ensure they were fed and housed, were often poorly treated. In 1885, money raised from the Metropolitan Board of Works was used to finance the expansion of the workhouse and infirmary, and gradually conditions for inmates improved. The Woolwich Road and Vanbrugh Hill workhouse became St Alfege's Hospital in 1931. In the late 1960s the red-brick Gothic-style buildings were demolished to make way for Greenwich District Hospital, a monstrosity of a building, constructed in sections of dreary grey concrete. This was taken down in 2006 to make way for a residential, community and leisure development.

UNESCO

For the older generation of Greenwich residents, including myself and many of my friends and relations, we were all proud of our town's royal and maritime history and heritage. However, it would not be until the late twentieth century that UNESCO (the United Nations Educational, Scientific and Cultural Organisation) acknowledged Greenwich's importance both nationally and globally by designating it a World Heritage site in 1997. Although formed in 1946, UNESCO's World Heritage Committee only began designating sites of international importance in 1978, in an attempt to preserve the world's cultural and natural heritage. Greenwich was chosen for its royal and maritime traditions and buildings of outstanding universal value.

Greenwich, a royal borough and World Heritage Site.

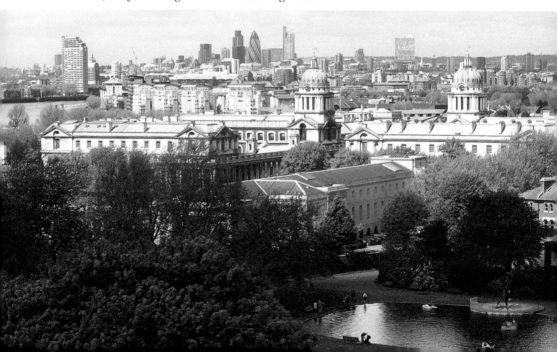

Following World Heritage recognition, to mark the Diamond Jubilee of Elizabeth II in 2012, Greenwich was granted royal status in acknowledgment of the historic links between the Crown and the maritime Thameside town.

Up the Creek

Stand-up comedians have performed in Greenwich since the early days of music halls, and long before this, while in residence at Greenwich Palace, kings and queens were entertained by court jesters and comedic theatrical masques.

Comedy act performances in local pubs and working men's clubs became popular during the early 1970s, and on Saturday evenings my friends and I would often go out to see young talented south-east and east London comedians perform at local pubs and clubs, including Jim Davidson, Mike Reid and Jimmy Jones. Gradually an alternative comedy scene evolved where unconventional comedians such as local lads Hale and Pace broke away from traditional joke telling to present fast-paced satirical humour, performed in old redundant buildings transformed into comedy clubs. These clubs included the Tramshed, a former tram depot at Woolwich; the Mitre, a disused pub on Blackwall Lane; and a deserted church hall on Creek Road, where Lewisham-born comedian, and some say father of the comedy club revolution, Malcolm Hardee opened 'Up the Creek' in 1990. Acts appearing at this popular venue included Russell Brand, Michael McIntyre, Russell Howard, Al Murray, Sarah Millican and a host of top musicians and alternative comedy performers.

In 2016, a £20 million housing development on Creek Road included the refurbishment and expansion of the legendary 'Up the Creek'. Although somewhat more sanitised than when run by Hardee, the building's unique purple-painted façade was restored to its original stock brickwork.

The Comedy Club 'Up the Creek' first opened in 1990.

Vikings

After Rome withdrew its legions from Britain, Angles and Saxons migrated from Europe to settle in the east of Britain. One group arrived and made camp south of the River Thames where a small Anglo-Saxon fishing village evolved at Greenwich. Soon Viking raiders were sailing up the Thames to plunder riverside settlements and the important trading port of London. Although King Alfred succeeded in recapturing the city in AD 886, the Danes returned during the reign of Ethelred the Unready. Sailing up the Thames once more, the Vikings moored their longships off Greenwich, setting up camp on a hill overlooking the river. Setting out from Greenwich, raiding parties attacked the prosperous settlements of Kent, looting and sacking Canterbury in 1012 and taking Archbishop Alphege hostage. Held prisoner at Greenwich for seven months, when the archbishop refused to allow a ransom of 3,000 pieces of silver to be paid for his release, the Danes, drunk on wine, began pelting Alphege with animal bones leftover from a feast. Mortally wounded and bleeding, Alphege was quickly despatched by a blow to the head with the back of an axe, wielded by a Viking who took pity on him. It was alleged a boat's oar, covered in the archbishop's blood, began sprouting blossom. The Danes took this to be a sign from God, then released Alphege's body for burial at Canterbury. By the twelfth century, long after the Vikings had gone, a church was erected at the spot where Alphege was believed to have been killed. The archbishop was canonised by Pope Gregory VII in 1078. Although there is little trace of Viking occupation of Greenwich,

A present-day Viking vessel moored at Greenwich Reach.

the location of Danish settlements can be traced to the place names of Eastcombe and Westcombe, close to Blackheath (comb, or comp, identifying a Danish camp). Viking ships continue to sail up the Thames today, but instead of transporting Norse raiders they now carry tourists visiting Greenwich, with the vessels mooring off the pier, close to where Viking longships once anchored over a thousand years before.

Vanbrugh

Known most famously as the architect of Castle Howard and Blenheim Palace, John Vanbrugh, after succeeding Sir Christopher Wren as commissioner of Greenwich Hospital in 1703, made Greenwich his home, designing an impressive castle and family residence at the edge of Westcombe estate.

Before turning his artistic hand to designing buildings, Vanbrugh wrote several plays, two of which, Restoration comedies, caused controversy due to their sexual explicitness and defence of woman's marriage rights. When young, Vanbrugh served in the Earl of Huntingdon's foot regiment; however this position was short-lived and from 1689 he worked clandestinely in plotting to replace James II with William Prince of Orange. When attempting to return to England from Calais in 1690, after carrying messages to William's supporters, Vanbrugh was arrested as a suspected English spy and imprisoned for over four years in the Bastille, Paris. By the time of his release, Vanbrugh exchanged for French prisoners, William had been crowned King of England. After an unsuccessful attempt to run a theatrical company, building a theatre to his own design at the Haymarket, Vanbrugh turned to architectural design despite having no formal training, working closely with Nicholas Hawksmoor, former clerk to St Christopher Wren. Shortly before his marriage in 1719, Vanbrugh planned the building of the mock castle, the design believed to have been based upon the Bastille, a name by which the building became known. Vanbrugh added several extensions to the building before his death in 1726, and further additions and alterations were carried out by a succession of owners before the property was donated to the RAF Benevolent Fund in 1920.

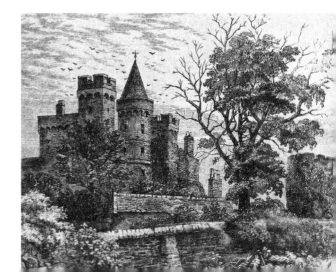

Vanbrugh Castle, Maze Hill, styled upon the Bastille, Paris.

Wolfe

One of the most famous heroic figures, well known by almost all schoolchildren of Greenwich, was General James Wolfe, who once resided at Mcartney House, Crooms Hill. Born in 1727, Wolfe's family relocated from Westerham to Greenwich where the young James Wolfe was educated before joining his father's 1st Marine Regiment as a volunteer at only thirteen years old. After receiving a commission as second lieutenant in the Marines, Wolfe transferred to the British Army Infantry, where, at the age of sixteen, he fought in a victorious battle over the French at Dettingen, Germany, his horse shot from under him during combat. Coming to the notice of his superiors while fighting in the War of Austrian Succession, Wolfe was promoted to the rank of captain. Recalled to Britain in 1746 to assist in putting down Bonnie Prince Charlie's Jacobite uprising, Wolfe led his regiment into action at the battles of Falkirk and Culloden, and was famed for refusing orders to shoot dead a wounded Highlander, exclaiming he would rather resign his post than sacrifice his honour. At the age of twenty-three, Wolfe attained the rank of major general and was appointed second-in-command of an expedition to capture the Fortress of Louisbourg, Canada, during Britain's Seven-Year War with France. After securing the fortress, the east coast of Canada came under British control, opening up a sea route for an all-out assault on French-held Quebec. Following a sea battle and long siege, Wolfe led a force in a surprise attack against the French on 13 September 1759. Scaling high cliffs, the British drove the French off the Plains of Abraham with musket volleys and a bayonet charge, the action lasting only fifteen minutes. Towards the end of the battle, Wolfe was struck down and mortally wounded by musket fire. As he lay dying, Wolfe gave out his final orders to secure the city of Quebec, then called out, 'Now, God be praised, I will die in peace.'

Wolfe's defeat of the French led to the capture of French-held Canada and the creation of Canada as a nation. The body of the hero of Quebec was brought home aboard HMS *Royal William* for interment at St Alfege Church, Greenwich. Hailed as a national hero on November 1759 to avoid his funeral becoming a massive public event, Wolfe was buried during the night in the family vault. Two schools – one in Greenwich and the other in Vancouver, Canada – were named after James Wolfe, and the impressive Grade II Wolfe statue of Greenwich Park, a gift from the people of Canada, was unveiled in June 1930 by the Marquis de Montcalm, a descendent of the French commander who also died during the battle.

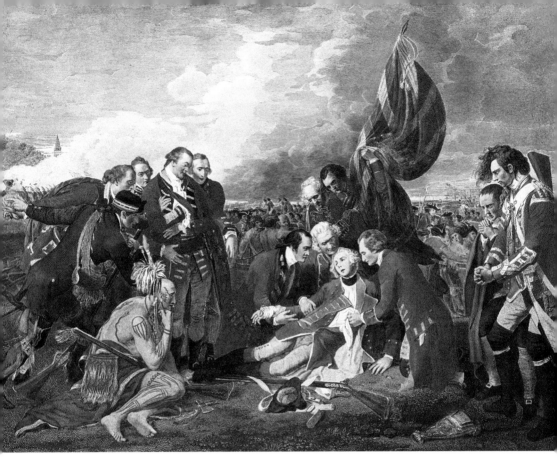

Above: The death of General Wolfe, Quebec, *c.* 1759.

Right: General Wolfe statue, Greenwich Park.

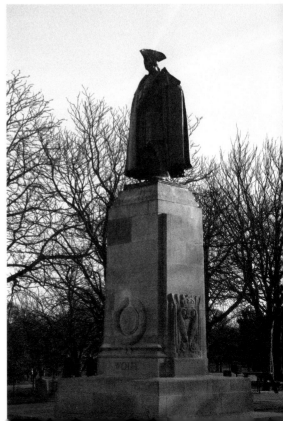

Whalers

Founded by Samuel Enderby during the late eighteenth century, Samuel Enderby & Sons, a family run sealing and whaling company, began hunting whales for their oil in the waters of the Atlantic with only one ship, the American–built *Almsbury*, renamed the *Rockingham*. The Enderbys started out as leather tanners at Bermondsey, south London, their finances raised by selling land in Ireland that had been acquired for supporting Oliver Cromwell during the English Civil War. After members of the family moved to Greenwich, a site was obtained on Greenwich Marsh to expand their commercial business interests through the manufacturing of rope and canvas to supply a fleet of whalers, many Enderby vessels between voyages mooring off Blackwall Point. The Enderbys encouraged their captains to combine whaling with exploration, sponsoring expeditions to the Southern Ocean and Antarctica, leading to the discovery of the Bellany Islands and the establishment of the Enderby Settlement at Port Ross, north-east of the Auckland Islands, and Enderby Island, now a nature reserve, located between Antarctica and New Zealand.

At the peak of their trading, the Enderbys operated sixty-eight ships. One, the *Samuel Enderby*, featured in the classic novel *Moby-Dick*, and another, the *Amelia*, sailed west around Cape Horn in 1789, becoming the first whaler to hunt in the Southern Ocean. The Enderbys erected a house on the river's edge, adjacent to the rope works, which had an unusual first floor octagonal room with a magnificent cast-iron and glass dome at the ceiling's centre, and a large bay window giving a panoramic view eastwards. Between the early seventeenth and mid-twentieth centuries the hunting of whales for their oil, meat and bone had been a respected and highly profitable industry, and the

The Whaler *Samuel Enderby*, launched in 1834, owned by the Enderbys of Greenwich.

Enderbys became London's largest whaling company. After many years of successful trading, the money invested in the unproductive South Atlantic Enderby Settlement eventually brought about the company's financial ruin and liquidation in 1854.

Watling Street

When the Romans arrived in Britain during the third century AD, they began a programme of road building to move men and goods out from the south-east, utilising an existing network of trackways predating Roman occupation by over a thousand years. One main trackway, which became Roman Watling Street, traversing Britain in a north-west direction from Dover to Anglesey, began as a broad, grassy trail once used by ancient Britons. In an article published by William Stukeley in 1722, whose archaeological studies of Stonehenge led to the theory the monument was erected by Druids, the physician, clergyman and antiquarian indentified the original Watling Street as running from Shooters Hill, the old road from Dover, through a section of Blackheath, close to a tumulus, then onwards into Greenwich Park.

Watling Street then ran directly past the remains of a Roman temple, possibly part of a military encampment, before dropping down into a landscaped area of parkland. Although the trackway was likely covered over during landscaping, a path has been worn through the grass showing a gravel surface over a compact layer of course gravel – park visitors today perhaps walking in the footsteps of ancient Britons. Continuing on towards the park's north-west boundary, the thoroughfare ran to the rear of the Spread Eagle Tavern and onwards to St Alfege's Church, continuing westwards and then turning sharply southwards to cross the creek at a deep ford, from which Deptford acquired the name.

The route of Watling Street through the centre of Greenwich Park, the sunlight placing the ancient trackway in shadow.

X-ray

Being an enthusiastic sci-fi fan from a very young age, a time when television series such as *Space Patrol*, *Doctor Who*, *Thunderbirds*, *Star Trek*, *Time Tunnel* and the *Outer Limits* were broadcast during the 1960s, after the Greenwich Royal Observatory first opened its doors to the public as a museum, my friends and I would often go there at weekends to look through telescopes and imagine what life might be like on planets in galaxies far, far away.

Since the opening of the Peter Harrison Planetarium in May 2007, digital light and film shows have given the public a visual experience of what it would be like to travel into outer space and visit other planets. The planetarium shows were created from information provided by space-borne X-ray telescopes and the technological advancements made in visual space exploration. Seating 120, the underground digital laser planetarium, accessed by the Weller Astronomy Galleries, stages various themed celestial sound and light shows throughout the year. High-energy astrophysics is a relatively young scientific field and during the fifty-year history of X-ray astronomy, the increasing resolution of telescopes has led to much higher quality digital images detailing clusters of galaxies, pulsar-wind nebulae, neutron stars and mysterious black holes – no longer objects of science fiction, but of science fact.

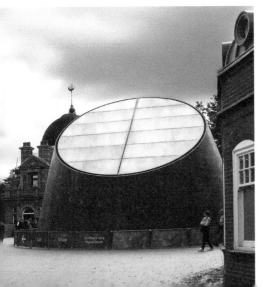

Royal Observatory's Peter Harrison Planetarium.

Y

Yarrow

By the time of my birth the shipbuilding industry along the Thames had long since gone, although a few smaller Greenwich yards continued constructing rivercraft and lighters up until the 1970s. One of Britain's major shipbuilding entrepreneurs, Greenwich resident Alfred Yarrow, who lived at Woodlands House in Westcombe Park during the late 1800s, established his first shipbuilding yard across the Thames at Poplar, east London, close to the place of his birth.

Although relocating the shipyard to the Clyde in 1908, Yarrow continued to live with his family at Woodlands, from where he oversaw his shipbuilding empire constructing destroyers and fast attack boats for the British Navy and governments from around the globe. Knighted in 1916, at the age of seventy-four, Sir Alfred Yarrow sold Woodlands and spent the latter years of his life making charitable donations towards funding schools, hospitals, a children's home and residences for soldiers' widows.

Below left: Woodlands, Westcombe Park, home of the famous shipbuilder Alfred Yarrow.

Below right: Sir Alfred Yarrow, early 1900s.

Yacht Racing

When two royal yachts set off from Greenwich in a race against each other on 1 October 1661, spectators watching from the Embankment were unaware they were witnessing the first ever recorded yacht race. Following the English Civil War, when the Royalists were defeated by Cromwell's Parliamentarians, Charles Stuart, son of Charles I, escaped across the Channel to the Dutch Republic. While living in exile he learned to sail Dutch jaghtes, fast-pursuit vessels, on the inland canals and along the coastal waters of Holland. After the Restoration, Charles II converted the coastal collier *Surprise*, the vessel he escaped from England aboard ten years earlier, into a smack-rigged yacht, the design based along the lines of Dutch jaghtes, renaming her *Royal Escape*.

Competing for a wager of £100, Charles II in command of Deptford-built *Katherine*, and his brother, the Duke of York, aboard *Anne*, constructed at Woolwich, sailed their respective vessels to Gravesend and back. According to John Evelyn, who accompanied Charles II on his yacht: 'The King lost in the going, the wind being contrary, but saved stakes in returning.' From Evelyn's account the first yacht race seems to have finished in a draw. By the time of his death in 1685, Charles II owned twenty-eight yachts, many of which he raced before transferred for use by the Royal Navy.

One of twenty-eight yachts owned by Charles II during his reign.

Z

Zero Degrees

For those born and raised in Greenwich, as well as those who visit the historic town, it is well recognised the Meridian Line dividing Greenwich east and west that marks the position 0° longitude.

The line, however, also represents the letter Z of global time zones, introduced during the early 1900s. Each zone was identified by letters of the alphabet and Greenwich time zone, the point of origin, is marked by the letter Z. The letter also refers to the zone description 'zero hours', and shipping and civil aviation use Z when referring to time at the Prime Meridian, pronounced phonetically as 'Zulu' time.

Marker indicating zero degrees positioned on Greenwich Park south boundary wall.

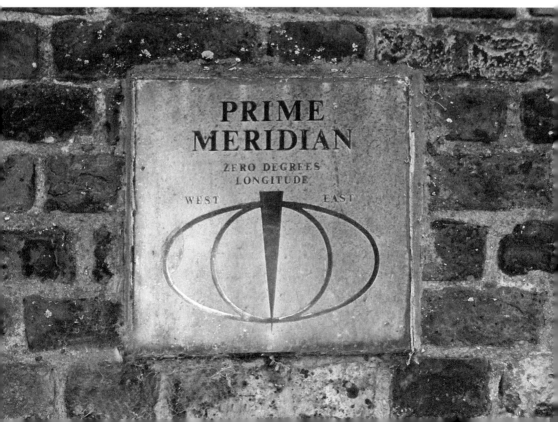

Zulu Wars

One of my first primary school history projects was making a model of a famous battle. After watching the film *Zulu* at my local cinema, the Granada, I decided to make a model of Rourke's Drift. The film was based on the defense of a mission station and garrison in South Africa, Rourke's Drift, by British Royal Engineers and colonial troops when attacked by warriors of the Zulu Kingdom. Of the garrison's survivors, eleven received the Victoria Cross, the highest award for gallantry in the presence of the enemy. The medals were made from bronze bosses of Chinese cannons, believed to have been captured during the Second Anglo-Chinese War of 1860, the cannons held at Woolwich Royal Artillery Repository. Just under six months after the defence of Rorke's Drift, a less well-known skirmish took place between the Zulus and a troop of British soldiers, commanded by Louis-Napoléon Bonaparte, Prince Imperial, a graduate of the Royal Military Academy, Woolwich. After the Emperor of France, Napoleon III, was dethroned in 1870 the French royal family were exiled to England, taking up residence at Chislehurst. Napoleon's only son, Louis, then joined the British army.

After attending the academy, the young prince served with the Royal Artillery before requesting a post to Africa, anticipating taking part in action during the Anglo-Zulu Wars. His superiors were reluctant to allow the Prince Imperial, last in succession to the throne of France, to serve in a theatre of war; however, supported by his mother, Empress Eugénie, as well as by Queen Victoria, his request was granted. Attaining the rank of lieutenant, the Prince Imperial, acting as an observer, was attached to the

Below left: Louis-Napoléon Bonaparte, Prince Imperial, prior to his posting to South Africa.

Below right: Thameside Guard House, Woolwich Arsenal, used as a temporary mortuary for the Prince Imperial in 1879.

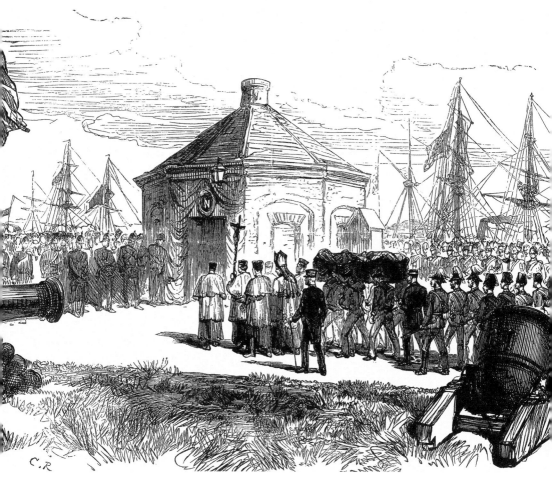

Return of the prince's remains to the temporary mortuary at Woolwich, late 1879.

staff of the commander in South Africa. After taking part in several reconnaissance missions on the morning of 1 June 1879, the Prince Imperial took command of the 17th Lancers scouting party, riding deep into the Zulu Kingdom.

Ambushed by Zulu skirmishers, the prince received a severe wound to his leg from a spear and, although firing upon his attackers, he was struck down and killed along with three escorts. After recovery of the Prince Imperial's body, his remains were returned to Woolwich Arsenal aboard a British troopship and placed within the riverfront western guardhouse, used as a temporary mortuary.

From there, the Prince Imperial was taken by funeral procession, attended by Queen Victoria, from Woolwich Arsenal to Chislehurst for burial. His body was later transferred to the family crypt at St Michael's Abbey, Farnborough.

Acknowledgements

I would like to thank all those who have contributed to this publication, providing information and giving permission for use of images. If for any reason I have not accredited people or organisations as necessary, I apologise for any oversight. I would also like to express my thanks to the following list of organisations, without whose help I would not have been able to produce this book: John Rooke, Audrey Mills and family, the Greenwich Heritage Centre, Caird Library & Archive – National Maritime Museum, the British Library, the Greenwich Industrial Heritage Society, the Cutty Sark Trust, the Old Royal Naval College, the National Archives, the London Encyclopaedia and British History Online, *A Vision of Britain Through Time*, Dover Publications Inc, Bloomsbury Ephemera Fair, The Royal Parks.